The Journey is the Destination.

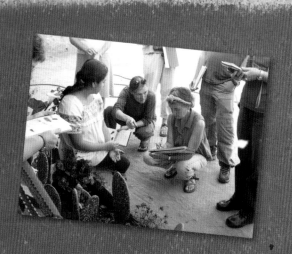

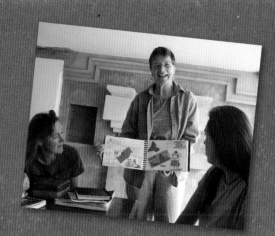

Also by Mari le Glatin Keis

Carnets de Bretagne – 1999
Quatre Saisons en Provence – 2000
Carnet d' Adresses Breton – 2001
Ma Bretagne au Fil des Jours – 2001
Mon Jardin Jour Après Jour – 2002

Illustrated by Mari le Glatin Keis

Children of Summer – 1997
Jean-Henri Fabre, Les Enfants de l'été - 2004

Library of Congress Cataloging-in-Publication Data

LeGlatin Keis, Mari.
 The art of travel with a sketchbook : six tips to get started / text by
Mari LeGlatin Keis ; illustrations by Mari LeGlatin Keis and workshop
participanats Karen Kenyon ... [et al.].
ISBN 1-57421-618-X (alk. paper)
 p. cm.
Includes bibliographical references and index.
1. Art—Technique. 2. Notebooks. I. Title.
N7430.5L435 2007
741.2--dc22
2007023381

10 9 8 7 6 5 4 3 2 1

THE ART OF TRAVEL

WITH

A SKETCHBOOK

SIX TIPS TO GET STARTED

TEXT BY MARI LE GLATIN KEIS

ILLUSTRATIONS BY MARI LE GLATIN KEIS

AND WORKSHOP PARTICIPANTS

KAREN KENYON - DIANNE ROTH - GEORGE NOREK - MIMI SHAWE - PRUE KAYE
NICOLE DENIS – MARILYN MADAU - CAROL CHAPEL - BARB CAMPBELL
MARGARET J. ANDERSON –BARBARA FOLAWN - SANDY SEGNA
JOAN ELISABETH REID - BETTY BERNARD - TED ERNST
SUZANNE McNEILL - ROBERTA WALLACE - KAREN KREAMER
MARY CAUGHEY - CHERYL MAZE - GALE EVERETT

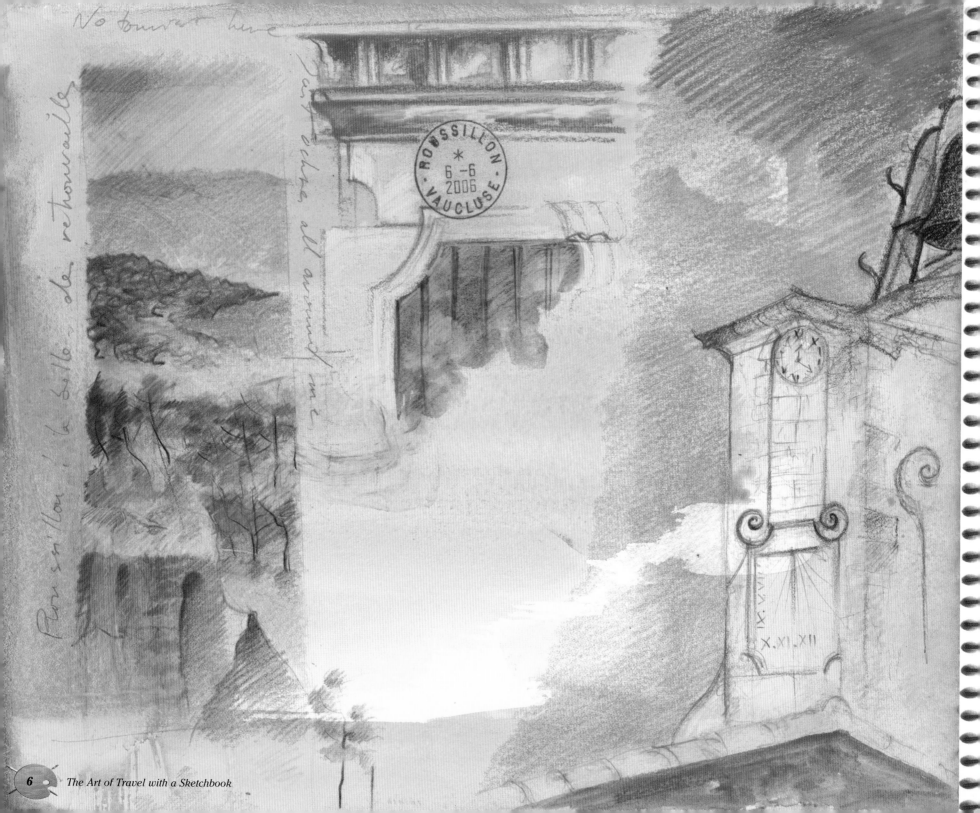

No louvrat here

ROUSSILLON
*
6 -6
2006
VAUCLUSE

Contents

ROUSSILLON
* 6 - 6 2006 *
VAUCLUSE

ACKNOWLEDGMENTS

First and foremost, I am indebted to my workshop participants. Without their enthusiasm and their contributions, this book could never have been written. They have inspired me to share my approach with others in book form. They let me borrow their sketchbook pages and their voices to illustrate the process; only they could do it. They are my teachers.

I am grateful to my husband Dick for his steady guidance and expertise throughout the writing/editing process. I owe a very special thanks to Dianne Roth for her patience in helping me to bring my computer knowledge up to task and to Margaret J. Anderson for her editorial help.

I would like to thank my publisher, Suzanne McNeill who, after participating in one of my workshops, trusted me to translate my approach into book form.

Finally, I thank my family, Dick, Joa, and Quena, and all my friends for their constant support and encouragement.

Mari le Glatin Keis
210 NW Kings Blvd, Corvallis, Oregon: 97330
Web site: www.artraveljournals.com

Published by Design Originals / 2007
2425 Cullen Street
Fort Worth, Texas 76107
First Edition - Printed in U.S.A.

"Nobody sees a flower, really – it is so small – we haven't time, and to see takes time, like to have a friend takes time."

Georgia O'Keeffe

A Few Words

Travelers' tales are as old as travel itself. Explorers described their expeditions with detailed illustrated maps and commentaries. Over the centuries, men and women, artists and naturalists recorded their adventures in their notebooks.

Now, we can travel anywhere in the world and find ourselves in a totally different culture in a few hours, but in this fast paced world, we need to slow down and better see and record what's happening around us. Photography has certainly made capturing the moment easy — with the click of a button, it is etched on film, or on a memory chip. But is it truly seen?

In recent years, people seem to want to add a new dimension to their travels, making them more meaningful, by capturing memories in a more personal manner. The tradition of traveling with a sketchbook has been rediscovered. Artists all over the world publish their travel sketchbooks and the market is flourishing.

But what about those of us who have no art training and want to record our travels in a sketchbook?

After years of leading sketching workshops and seeing people with no art training become so bold and confident, what at first was an intuition, is now a certitude. Sketching is not about doing "good" drawings or paintings. It is about being in the moment, about putting aside expectations and judgment and letting the hand record what the eyes see with whatever tool you have available, without rules or recipes. You do not learn "how to" sketch, you sketch. Over time your eyes train themselves to see. I have seen people of all ages jump into the amazing adventure of recording what they see, laying the most innocent lines and brush strokes in their sketchbook.

At times, I envy their pure and spontaneous renderings. They don't have to sort out all kinds of academic skills that were taught in school. The fewer techniques you know, the freer you are to experiment and play. By observing my participants over the years, I have developed an approach to sketching that is very simple. It only requires trust in oneself and ultimately, the desire to travel differently.

In the process of making this book, I found my way back to when and how I first fell in love with lines and drawing. It was in France, I was ten years old, sitting on a grammar school bench. A dissected frog was laid out on a table and our assignment was to carefully draw the exposed organs of the dead amphibian. Nervous giggles and groans of disgust filled the classroom. However, instead of being repulsed, I found myself fascinated by the complexity and perfection of those innards. I took my pencil and started drawing. Following the lines, dutifully going up, down, and around, my hand caressed the outermost edges of intestines and organs. Soon, I was no longer seeing a frog's digestive system; instead, I was seeing mountains and winding rivers.

I lost track of time; my hand had taken over and was doing the drawing.

When I entered the classroom the next morning, a surprise awaited me. My drawing was hanging on the wall as an example; I felt proud and it was my breakthrough. From that day on drawing would be my passion, my refuge while growing up. It was back then that I learned that you do not have to be talented or gifted to explore the wonders of sketching. All you need is to feed a passion that gives meaning to your life and offers a way to find happiness and creativity.

Growing up, I kept doodling and drawing. With academic training, I learned how to draw the "right" way. Later, I studied printmaking. It seemed like a logical choice considering my passion for lines and drawing. I came out of art school numb and frozen from the pressure to do "right and beautiful". I went off to South America to draw plants and flowers rather than pursuing a teaching career. One year stretched into four. All I had was a sketchbook and a few pencils. I started filling pages with my observations and documented everything I saw: the fauna, the flora and the people. Sketching gave me a "raison d'être," a purpose. I could live among the natives high in the Andes or deep in the jungle without feeling like a "voyeur".

Wherever I went, children gathered around to see what I was doing, how I viewed their world, and they were delighted when I offered them my pencils to try their hand at sketching.

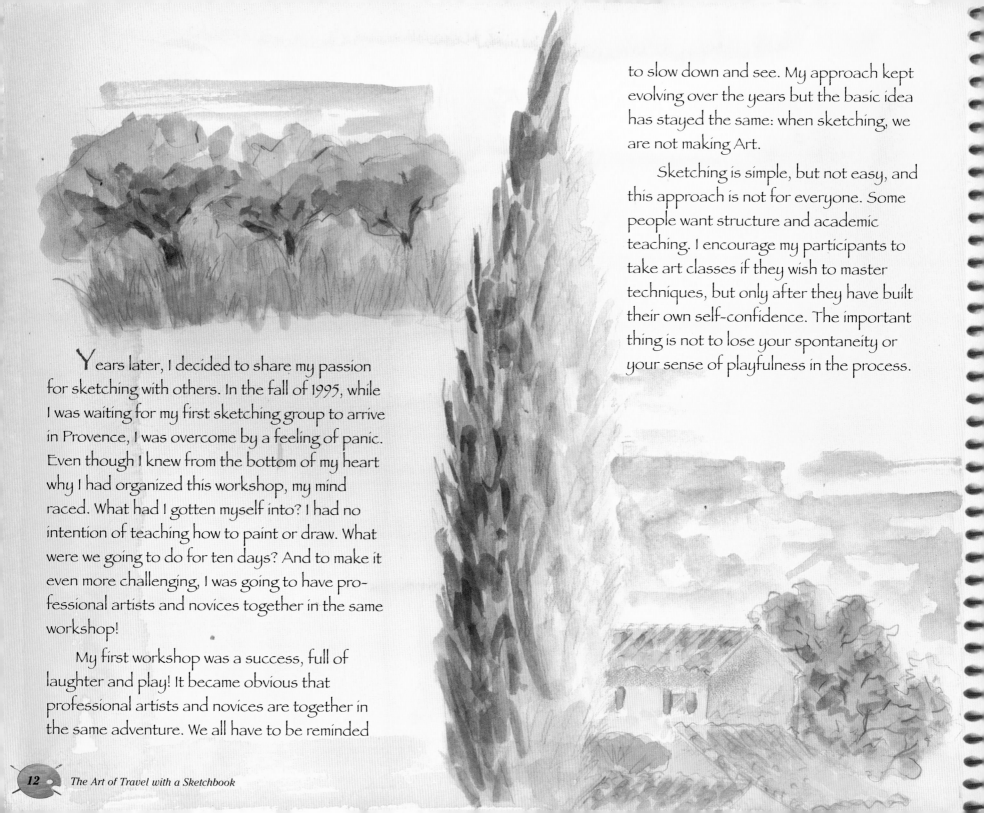

to slow down and see. My approach kept evolving over the years but the basic idea has stayed the same: when sketching, we are not making Art.

Sketching is simple, but not easy, and this approach is not for everyone. Some people want structure and academic teaching. I encourage my participants to take art classes if they wish to master techniques, but only after they have built their own self-confidence. The important thing is not to lose your spontaneity or your sense of playfulness in the process.

Years later, I decided to share my passion for sketching with others. In the fall of 1995, while I was waiting for my first sketching group to arrive in Provence, I was overcome by a feeling of panic. Even though I knew from the bottom of my heart why I had organized this workshop, my mind raced. What had I gotten myself into? I had no intention of teaching how to paint or draw. What were we going to do for ten days? And to make it even more challenging, I was going to have professional artists and novices together in the same workshop!

My first workshop was a success, full of laughter and play! It became obvious that professional artists and novices are together in the same adventure. We all have to be reminded

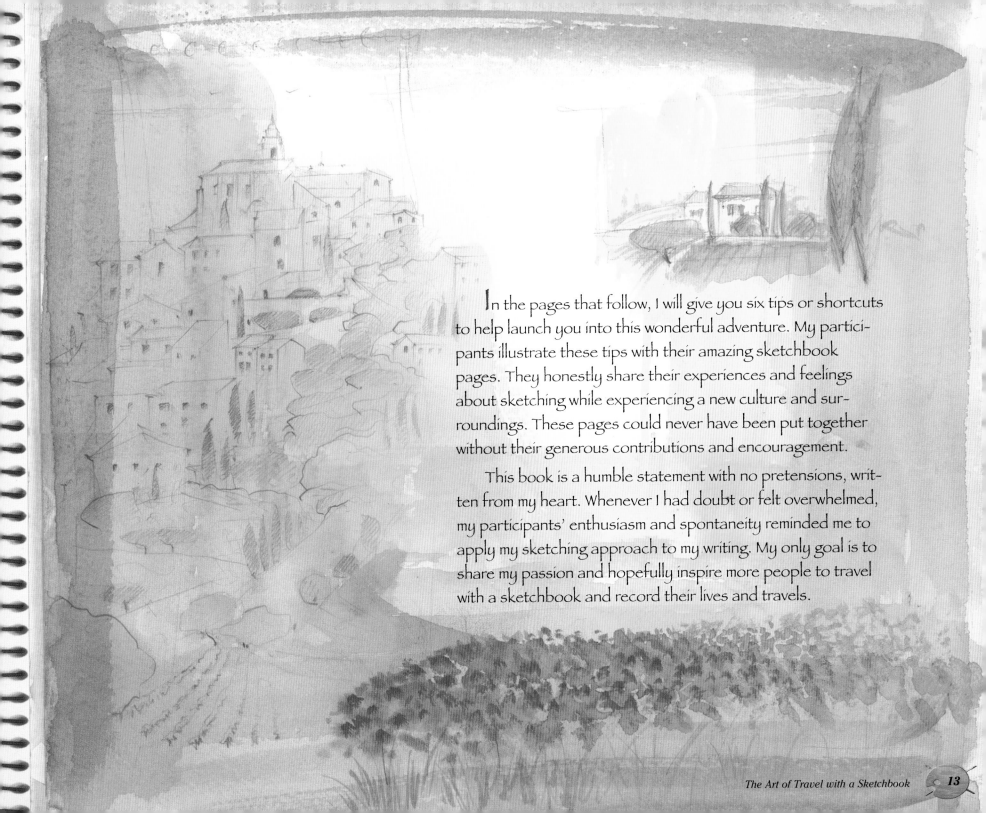

In the pages that follow, I will give you six tips or shortcuts to help launch you into this wonderful adventure. My participants illustrate these tips with their amazing sketchbook pages. They honestly share their experiences and feelings about sketching while experiencing a new culture and surroundings. These pages could never have been put together without their generous contributions and encouragement.

This book is a humble statement with no pretensions, written from my heart. Whenever I had doubt or felt overwhelmed, my participants' enthusiasm and spontaneity reminded me to apply my sketching approach to my writing. My only goal is to share my passion and hopefully inspire more people to travel with a sketchbook and record their lives and travels.

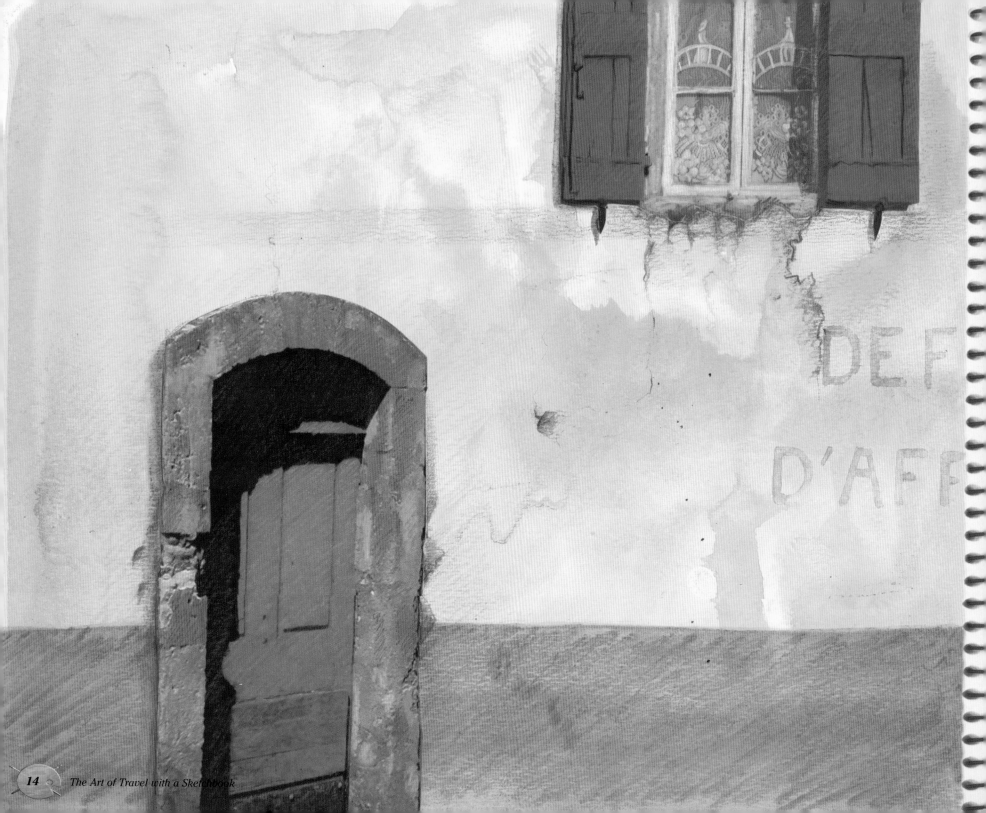

Six Tips To Get Started...

1. Pack Light & Simple

2. Relax

3. Play with Color

4. Stay Small

5. Collage

6. Sketch with Words

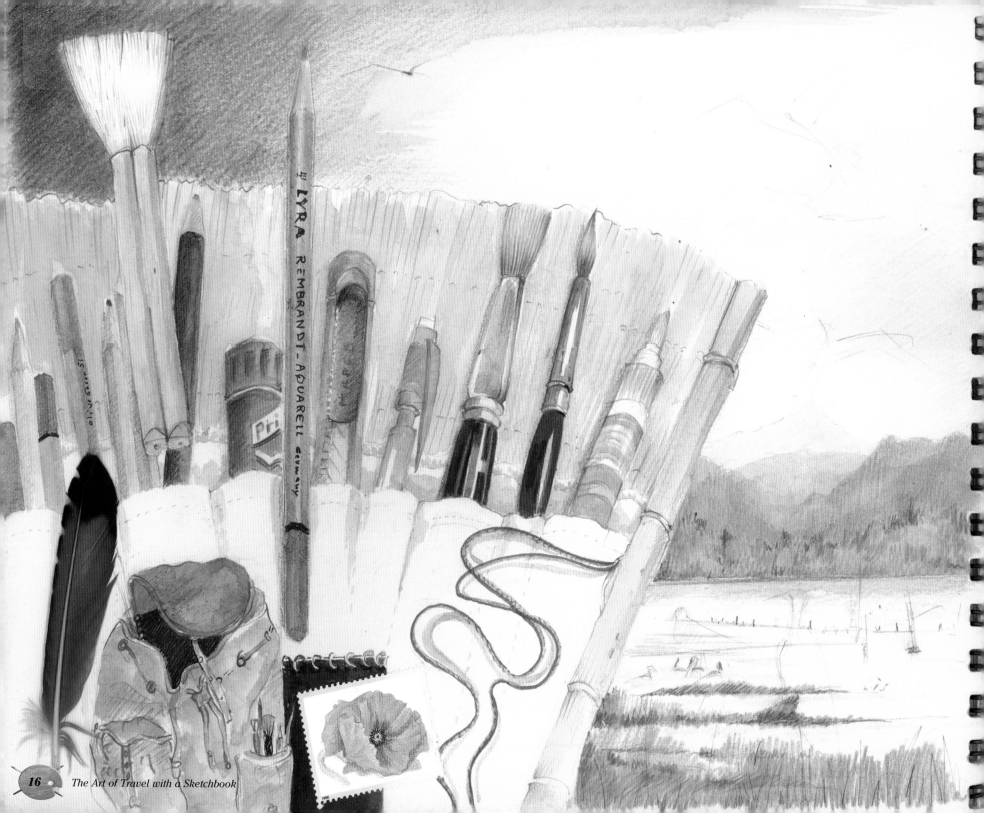

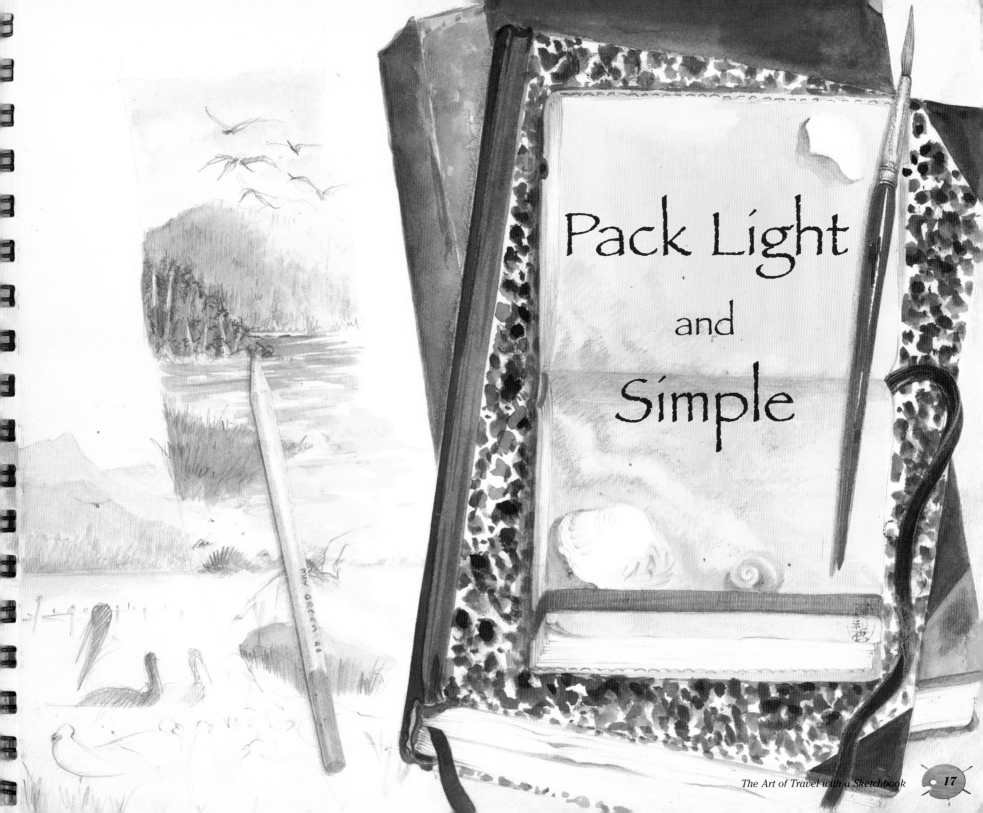

Pack Light

and

Simple

Choosing your supplies...

Sketching while traveling is simple. You do not need much and you will surprise yourself with what you can do with a small amount of supplies. If you are starting this adventure, you may want to try different tools before you go on your sketching trip. Ultimately, your hand will choose the tool that you will feel comfortable with.

Over the years, I have observed that I use the same tools and keep eliminating the extras. The ones I keep become my companions, I can trust them to record what I see and feel.

In a boat on the Dordogne
5¼" x 8¼" pastel & color pencils on tan paper

The castles of Gageac, Castelnaut, Marquesac hang on the cliffs like ghosts... I quickly sketch Castelnaut with my pencil; a green soft pastel allows me to cover most of the foreground in a few seconds.

In the caves, back in time...
5¼" x 8¼" pigments from the red soil & color pencil on tan paper
Pech Merle, Dordogne, France.
It is completely dark around me except on the wall.

I dig my brush into the red soil and I contour the shapes of prehistoric beasts with a black and red pencil.

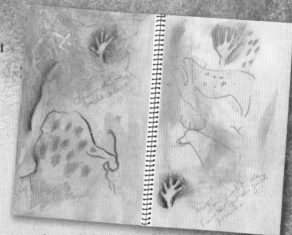

Bag: a backpack or a shoulder bag

Either one you choose, keep it small. It seems like the bigger it is, the more we stuff in it. Don't forget that you will have to carry whatever you take throughout the whole day of sketching. I like my bags to have several pockets or compartments. A backpack has the advantage of freeing your hands, but a shoulder bag gives you easier access to your tools when you want to capture something quickly. I also like to keep some space in my bag for small treasures I find on my way and for supplies I find on site.

Let it happen!
9" x 12" collage, oil pastels, gouache

Monte Alban, Mexico

Early that morning, I glued a whole page from a local newspaper on the left page. I intentionally left some text to show through. I used white gouache to paint the "pajaro bobo" flower and color pencils to shape the old couple sitting under a tree.

On the right side, I glued a page from a 5 x 8 tan colored sketchbook representing Monte Alban under a threatening sky! The head was done with oil pastels. I remember coming down from Monte Alban later that day and noticing that I had not drawn the pyramids! I realized that it was the location of Monte Alban that made the grandeur of the place. I did not need to draw the pyramids; they were imprinted in my visual memory.

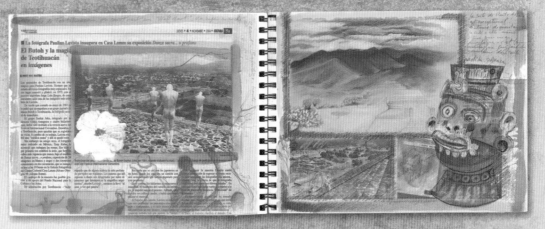

Sketchbooks:

I recommend having two sketchbooks when traveling, one that fits in a pocket and a larger one that fits in a bag. There are three sketchbook formats available in most art stores: portrait, landscape and square. They are all great in their own way; all sketchbooks come either spiral or bound. They both have advantages and drawbacks. You may want to try both before you leave so you can see what suits you the best. But whichever you choose, it should be hard back. Some people like to have different papers in one sketchbook and make their own. I actually find that each country and culture inspires me differently and tends to determine the choice of formats, papers and mediums I use.

If you decide to buy your sketchbook, my advice is to look for a paper that is thick and smooth enough to be used for a variety of media: pencils, pastels, collage, and watercolors. The quality and thickness of the paper is not as crucial for your pocketsize sketchbook, as those small pages may be torn and glued into your bigger size sketchbook. When you reach your destination, you will have all kinds of papers available to you: recycled, hand made, white, off white, tan or colored, old books and newspapers. The choice will be wide and they will all be fun to play with. You may even use an old book and draw and paint on every printed page. You can use white gouache to cover some of the text; and leave some of the words to come through. You can glue different paper on some pages.

Keep some room for all the treasures you will find along the road. You may even want to create a pocket in your sketchbook for them. Simply glue or tape a piece of paper onto the end cover, either front or back. You can do anything you want!

Tools:

I keep my tools as simple and portable as the rest of my equipment. Don't forget that when you get to your destination, you will find local pigments to use on your pages.

In my pencil pouch I have a 0.5 and a 0.7 mechanical pencil with HB lead. They both give me a big range of nuances between blacks and grays, depending on the pressure I apply. I always make sure that I have a waterproof pen, a No. 3 Faber Castell artist pen or a Pigma Graphic "2".

I take a regular small watercolor set and 2 brushes: a thick one and a small one. I sometimes use white gouache to cover newsprint. A medium water reservoir brush or travel brush is very handy when you decide to take a minimum of supplies along. I use an empty film container for water and a small rag to clean and dry my brushes. I also like to have a dozen watercolor pencils and a few dry and/or oil pastels to experiment with. Oil pastels have the tendency to melt in hot climates, but that inconvenience can be used for textures!

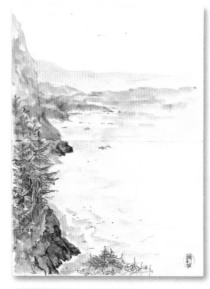

I feel so humble in front of nature!

4¼" x 6"

Oregon coast.
I held my sketchbook vertically to better capture the height and the "grandeur" of the place. I quickly sketched the scene with my 0.5 technical pen, added a few watercolors, and finished with a few black lines from my Faber Castell artist pen for the deep black rocks down below.

I still hear the wind blowing through the high grass...

6" x 10"

High Desert, Oregon
A very quick sketch, done with a .05 technical pen and a sand ocher pastel for the high golden, grass.

Just a few seconds for these two little landscapes

3½" x 4¾" .05 technical pen and watercolor.

Pacific Northwest

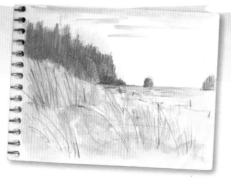

For a pencil sharpener, I use an X-acto knife. I find that it does not eat your pencils as fast as a regular pencil sharpener.

Don't forget:

- A glue stick and an envelope to gather little treasures that you may find here and there.
- A bamboo holder for color pencils and brushes and a pencil pouch to carry the rest of your tools.
- A couple of large clips to hold paper in place.
- A foam gardening pad to sit on or a folding chair if needed.

From here, Gordes has not changed since the Middle Ages

10" x 10" pencil & color pencil

Provence, France

All of these supplies should fit in a small backpack. Some days, I feel like having a variety of tools on hand and pack whatever I am in the mood for. There are many days, however, when I only take my pocketsize sketchbook and a pencil, I may slip my watercolor set in my pocket, a medium travel brush behind my ear and start my sketching day.

So, remember: the simpler, the lighter, the better.

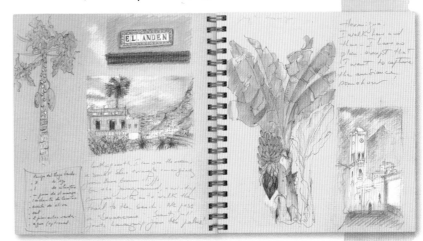

A quiet afternoon in Hermigua

10" x 10" watercolor pencils on tan paper

La Gomera, Canary Islands, Spain

PARTICIPANT PAGES - PACK LIGHT...
KAREN KENYON, DIANNE ROTH, GEORGE NOREK, MIMI SHAWE, PRUE KAYE

*T*eenagers practicing traditional dances swirled in front of us one evening in the park. Trying to catch the energy and movement of the group, I sketched page after page of a small sketchbook using only my pen.

Sensing someone behind me, I looked up to see a little girl peeking over my shoulder. She beamed and said in perfect English, "Hello. My name is Rosa." Then she scampered back to her smiling father. One draws sketches on paper—and draws others into conversation! This is one of the delights of sketchbook travel.

Karen Kenyon, 2004

Oaxaca, Mexico - I tried to make composite drawings to catch the movements and costumes of dancers as they whirled across the stage.

While traveling by train from Paris to Munich, I took out my sketchbook. I wanted it all in my journal, but my pencils and my eyes were not enough. Mari insisted that sketching is not about the aesthetic. It is only about my experience. But, in my heart, I knew I was not the artist I longed to be.

I chose my favorite pen and made small boxes to record vignettes of the countryside. Each small box was filled with tidbits. I would sketch a barn, but that scene was quickly gone. I added a house that caught my eye, and when that was gone, a corner of a field.

At one station I saw a man with a cane walking toward the train. He was so elegant that one of my boxes would be too small for him. I put him along the spiral, adding boxes as if he was walking across the page in front of them.

As I sketched with only my pen, I got lost in the scenes racing past my window and appearing in pieces in my sketchbook. I was unaware of anyone or even that I was in a train car. Everything was about recording what my eye could see. Then, as a family behind me prepared to exit at a station, the father leaned over and whispered how much he had enjoyed watching me sketch.

I looked at my page and Mari's words come back to me. "It is not the aesthetic." I got it! It is my life on this page. It is my experience, my connection to my world. It doesn't have to be beautiful art. But, it is all there! And, even now, as I sit in Corvallis, this page comes alive with sights and sounds and a reminder of a wonderful day traveling through the beautiful French and German countryside and a father who whispered in my ear.

Dianne Roth, 2005

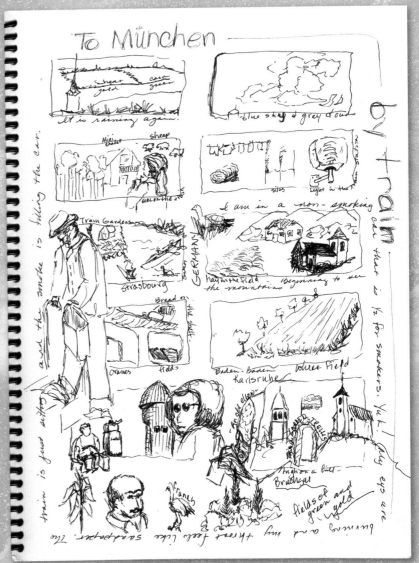

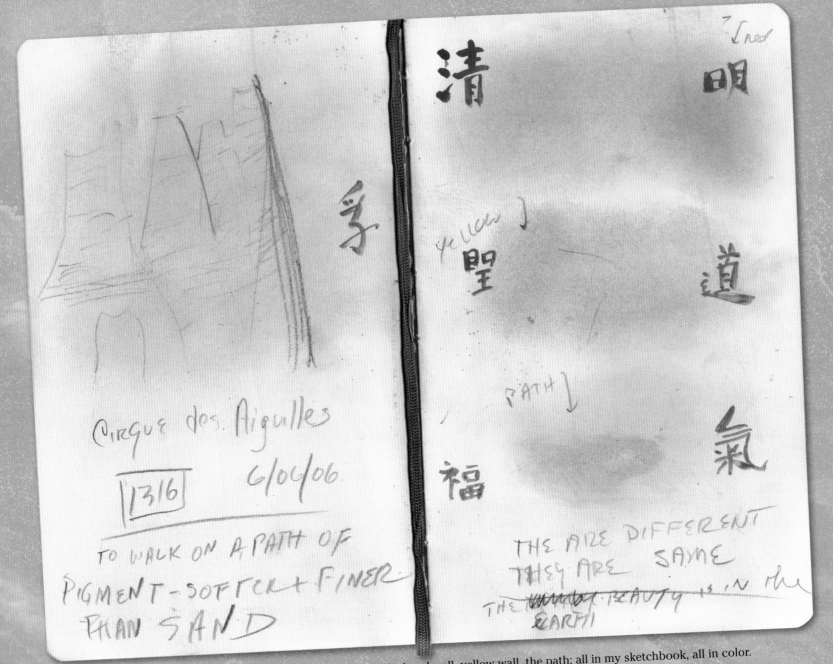

清 明

[red]

手 聖 道

yellow

福 PATH

氣

Cirque des. Aiguilles

[1316] 6/04/06.

TO WALK ON A PATH OF
PIGMENT-SOFTER + FINER
THAN SAND

THE ARE DIFFERENT
THEY ARE SAME
THE BEAUTY IS IN THE
EARTH

"I shall rub the pigment onto the page of my sketchbook. It worked; red wall, yellow wall, the path; all in my sketchbook, all in color.
My fingers were wonderfully colored. The location noted with my #2 pencil."

I've never sketched. I am an oriental calligrapher of many years. I practice daily. The key to each Chinese character is its essence; though it may be written with certain casual liberties, it is always identifiable. In Roussillon, I carried nothing but a #2 pencil and sketchbook. The view of the hillside village and dizzying angles, roofs, and shadows, overwhelmed my #2 pencil. And, then, enlightenment! Roussillon is not about buildings and churches or wonderful cafes.

It is about pigment. I set out to capture this in my sketchbook. As I walked the path, I walked by many other visitors. I sensed that I walked in pigment; red, very fine, softer and smaller than sand, but gritty. It was very loose and forced me to walk slowly and mindfully. I looked around, the walls of the canyon were brilliant yellow and red-brown, but how could I capture these walls, resonating with color, with my #2 pencil? And then, an idea. I shall rub the pigment onto the page of my sketchbook. It worked; red wall, yellow wall, the path; all in my sketchbook, all in color. My fingers were wonderfully colored. The location noted with my #2 pencil.

After the walk, I visited a shop that sold pigments. I asked for the natural color of Roussillon, the color of the path of pigment. From a rainbow of pigments on the shelf, the clerk chose an inexpensive, somewhat dull and uninteresting bottle of brown-red powder. I learned that it needed to be mixed with gum Arabic, so I purchased the powdered form. Simple instructions in French were on the jar. I identified "3 + 1", the rest I could not read. I used the proverbial "pinch", one of gum Arabic, 3 of pigment, a few drops of water, and the end of my brush to stir. Voilá, it was done! I went on to write Chinese characters with spiritual meaning beside my patches of pigment. They were brilliant and alive, and the same as the path.

Grapevines in Roussillon, France
"I brush-sketched them with the pigment of the path."

As I looked up from the page, I looked down the perfect rows of grapevines. I brush-sketched them with the pigment of the path.

George Norek, 2006

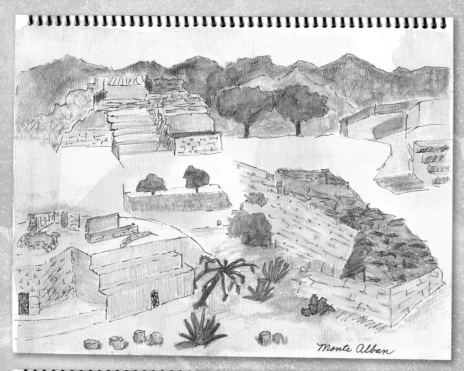

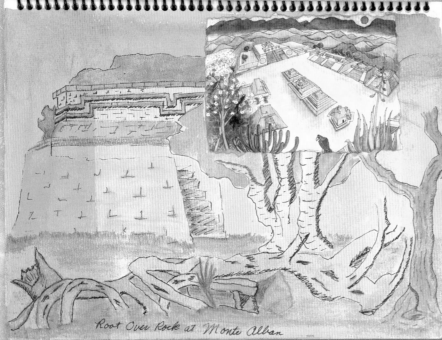

Root Over Rock at Monte Alban

Oaxaca, Mexico. One day at Monte Alban

*T*he idea of traveling light has been, and will probably continue to be, a work in progress.

For the first trip to Oaxaca I just went to the art store with Mari's list of suggested items, got those, and then went off the list buying other interesting things. I went to Oaxaca with about five or six pounds of supplies, only two of which were sketchbooks! The first day there, I knew I needed a small watercolor set, so bought it locally. Because we had time in the evenings to play with our sketches, I used most of the items I had with me. One of my favorite parts of the day was to do my painting/collage work in the evening.

A few months after Oaxaca I took a 10-day trip to Peru, not an art journaling trip, so knew I wouldn't have time for evening coloring. I only took my large and small sketchbook, one small container of pens and pencils, small watercolor box, two brushes, two water reservoir brushes, 72 colored pencils, glue, and small scissors. Everything weighed slightly over three pounds, but was more than I needed. I made notes to myself to take less next time because I didn't use all of the items I had with me.

On my most recent trip, three weeks in China, I took only one large sketchbook, the small container of pens and pencils, and the colored pencils, down to two pounds, but again notes to myself—TAKE LESS.

I'm planning a trip for the fall and will only take the pen/pencil container, small watercolor box, and one sketchbook. This weighs about one pound and I could go lighter if I take only two pens and two pencils. Like I said at the beginning, this traveling light is a work in progress, but oh so fun!

Mimi Shawe

Traveling light with a sketchbook (and no camera) puts me at an easy pace. Relax and look, and look some more. A quiet afternoon in Monte Alban gives me permission to see with new eyes. I had never tried to draw and I was so nervous that my hand was shaking. Taking a deep breath, I just got started. I had only a small sketchbook, a black pen, and a small watercolor set. People paid no attention to me and they were my first targets.

I soon found that I like to draw what I like most: people, dogs and plants. Contours and action: tiny lines, a mere suggestion of the shape and movement. I am reminded, when I look at my small sketches, of the fresh air and the energy of all the people in the ancient ruins of Monte Alban.

Prue Kaye

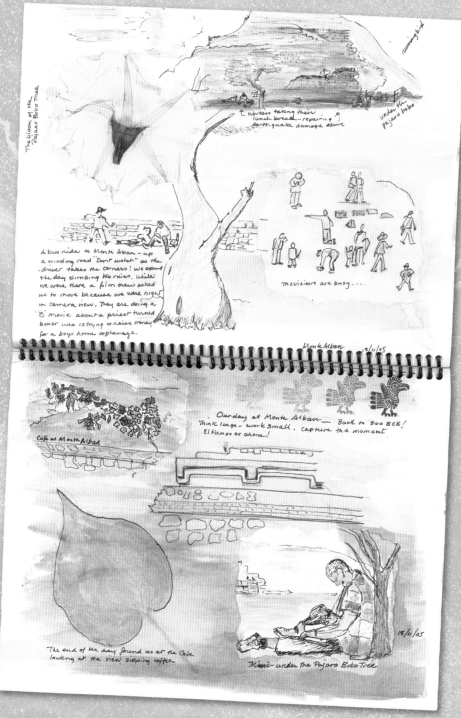

Teotitlan del Valle, Oaxaca, Mexico
Prue playing with pigments at a women's weaving collective.

✝ XO M CC LXXVS
OL

Abbaye St Nicaire

Whenever I look at...
I can hear... Slow and...
voices! beautifully... haunting.
une chanson, en occitan du
XVI siecle found in Notre dame
des Doms en Avignon,
life cycle

A Ra de manjar que n'avem,
ave de manjar que n'avem
ava faire per cantar,
coma faire per cantar, coma faire
la Singoletta, la Singoletta,
per cantar...: coma faire per dansar,
puis: coma faire per pregar, per morir...

84 LACOSTE
* 8 -6
2006
VAUCLUSE

Relax ...

Slow Down ... Observe ... Record...

Now that your bag is ready, here are a few tips that will help you relax and give you confidence to start this adventure. To record what you see requires your total attention and awareness. Only when your mind and body have relaxed will you be able to start sketching.

Be gentle with yourself and allow yourself to be fully in the moment. In sketching, there is no expectation, no performing, no good or bad. There is just the pure pleasure of describing life as it is. Trust yourself and play. Behind every page, there is a moment, an emotion. No matter how "good" or realistic your rendering is, a simple line or color will bring you right back in the moment. You will be able to see, hear, feel, and smell. Your sketchbook pages are valuable for what they are, not for what they could become on a larger scale or a canvas. Whatever is done is done. It is right because you did it with your own lines or words; it is your own interpretation.

The beauty of a sketchbook is that it is your very own, a place where you can be totally yourself and free. Nobody has the right to judge if or when a page is finished or beautiful. Nobody has the right to tell you that you should sketch every day. No matter how undisciplined you are, your eyes will train themselves to see and your ability to draw will improve.

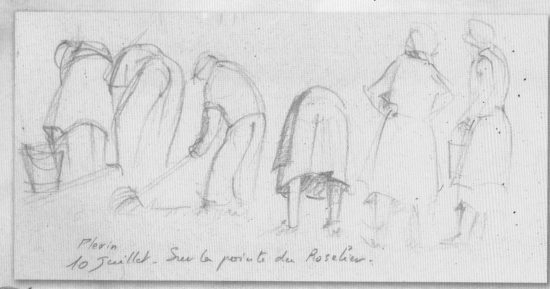

Plérin
10 Juillet - Sur la pointe du Roselier.

At home in Brittany…

Riding my bicycle to "la pointe du Roselier" to sketch. In a field a couple of old people is digging potatoes. That scene is so familiar to me that I want to capture their gesture. I stop my bicycle, grab my sketchbook, a pencil and start sketching.

The woman stands, sees me, and rests her hands on her hips. Her stare says: "Why don't you make yourself useful and come help." She bends back to her work, but I feel awkward and leave…

Extracted from "Carnets de Bretagne" 1999

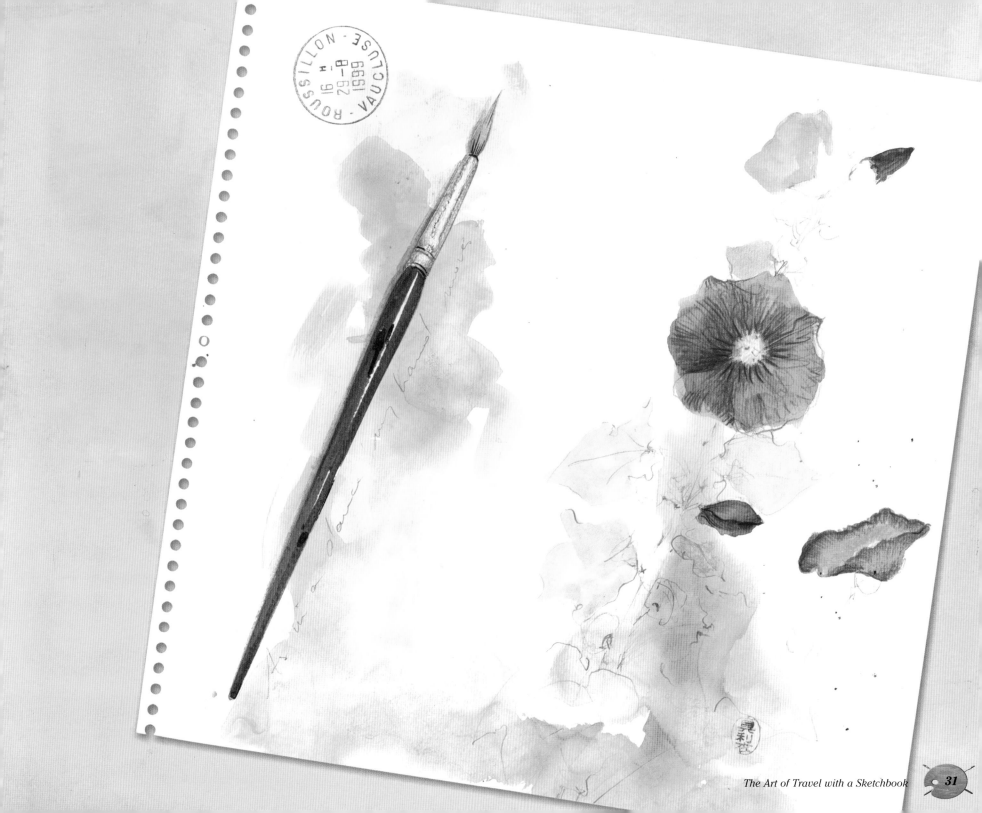

There are two exercises that can help you relax and increase your awareness. They are called "contour" and "gesture". Both exercises are equally relaxing. They don't need your left brain to intervene. At first I was reluctant and skeptical to include these two exercises into my approach until I realized that I was using them intuitively, before I even knew that they had a name. Contour and gesture are essential to seeing and recording. They will increase your awareness; small details that you took for granted or failed to see will jump into your sight.

Before I demonstrate these two exercises, I remind everyone that we have more than our eyes to see. On the first day of a workshop, I invite my participants to walk around slowly without any art supplies and to sketch with their eyes as if they were pens and brushes. There's no judgment, no critical mind, no expectation or anxiety for that first page to be filled. There is just you and what you are seeing. Don't hesitate to move your pen-less hand and sketch in the air. Sketch with your whole body as if you were dancing.

The second step is to find a place where you can sit quietly, close your eyes for a few minutes, and have your sketchbook open on your lap with a pen in hand. When you are ready, open your eyes slowly and stare at whatever is in front of you. Observe the entire contour, shape, and color of what you are looking at and focus. Place your pen on your sheet of paper and let your hand move. Explore inside and around, fill up the whole page with your lines. Your pen is now gliding, happy and free. Try not to lift it or look at your page. This could cut off the flow between your heart and your hand and allow your critical and logical mind to interfere. By now, you are totally connected with what you are seeing. If your

How to make time fly!

6" x 12" watercolor & pencil
Flying over the Cascades, looking through the window… beautiful, white-capped mountains and clouds unfold under my eyes. My hand dances onto my page. I am stunned when the captain announces: "Preparing for landing!" Two hours have gone by!

hand is drawing outside the edge of the paper, don't stop, your eyes are still seeing! When you look at what you've done, you may not recognize what you were drawing and laugh at the rendering. But if you look closely, without judgment, you'll see that you have caught the essence of what you were drawing. Contour is meditative. You let your heart, your eyes and your hand do the drawing and you are totally in the moment.

Gesture is a similar exercise but done in fast action. When you practice "gesture", you record as much as possible, anything that catches your eyes, quickly, in one breath. For example, if you are drawing a man who is crossing the street, you don't look at the clothes he's wearing, but at what his body is doing. Then quickly, without thinking, you capture the movement with a pen or a brush.

Contour and gesture make a great daily warm-up. Keep them in mind throughout your sketching day. For both exercises, I use a Faber Castell Pitt artist pen or a Pigma Graphic "2". They both "run" fast over either smooth or textured paper and since they are waterproof, they give you the option to add colors if you wish.

Whenever you feel frustrated, move on and breathe deeply. Sit in front of a wall or a tree and focus. Follow the lines, the cracks. Discover a small world, right there,

right then. In a plane, a train, a bus, take your sketchbook out, one pen and start sketching. You will be amazed how time flies by!

I think that the important thing is to keep finding joy and pleasure in sketching. We have to chase that little devil, that critical mind, judging, telling us that what we are doing is wrong and trying to ruin our enthusiasm. Whenever I look at my pages, I can recognize and remember my mood of that day. Curiously, the ones I have the most pleasure looking at reflect a good day, a day when I was singing and humming, totally in the moment, allowing beauty to come through.

Instead of saying, "I like this page", I say, "I loved this day!"

A few lines or colors are enough to bring you back…

9" x 12"

Playa Zancudo, Costa Rica
Last day on the beach. I feel like I should do a last page before I leave. My hand reaches for the brush and watercolors. I quickly spread a blue and green wash around the page and stop. That's all I can say! Years after, I look at this almost empty page, and it all comes back, the smells, the blue sky, and ocean. I hear the flapping wings of a bird flying across the sky. The blue wash alone has imprinted that day in my memory forever!

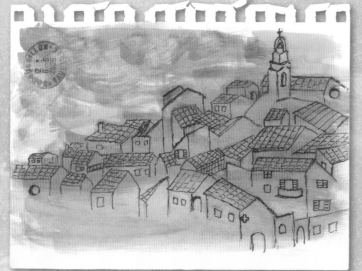

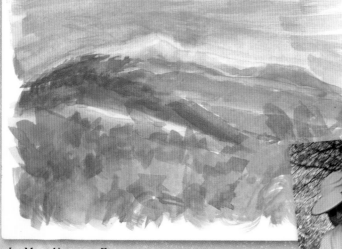

Le Mont Ventoux, France

I never sketched before and I didn't think I was able to. I joined Mari's workshop in Provence knowing it would be a challenge for me. Mari told us to relax, and sketch as we felt. I was skeptical, but it worked! In the village of Roussillon, I was enthusiastic because of the ochre colors. I began sketching some brightly colored houses. I was seated on a low wall, drawing, mixing colors and answering the questions of young German children who seemed to appreciate what I was doing: My first...admirers! It was great!

A few days later, after a picnic under the shelter of some pine trees, I began sketching Gordes. There, it was the shape of the hill, the houses scattered among the trees, I wanted it all but Mari just said, "It's not necessary to draw every detail, translate your impression". And here is the result!

During the ten days of the workshop, I felt less and less "shy". The last evening, as I was sketching the Mont Ventoux, Mari said, "Let go," and I did! There's something of Cézanne, don't you think?

What I appreciated most was the freedom; there was no judgment, no rule; nothing was compulsory. Our only "law": relax and be happy! I am different now: I learned to look at everything with new eyes, I do "contours" in the air and I often ask myself, "How can I sketch this...and this?"

Nicole Denis,
French participant,
2006

Roussillon, France

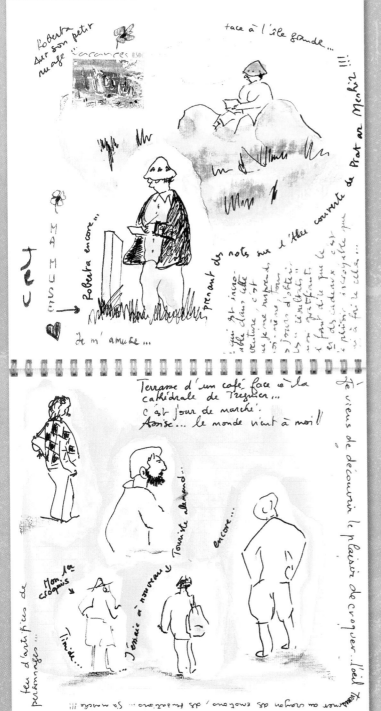

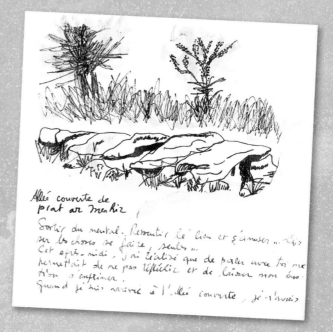

I joined Mari's Brittany sketching workshop in June, 2004. It was my first time sketching ever, and I did it! I learned how to let go of my left-brain and let my emotion express itself.

What is amazing in this adventure is that I surprise myself every day to actually be satisfied with my pages. I have to say the best of it all is the fun and pleasure I get doing it.

Marilyn Madau,
French participant, 2004

I enjoy drawing. Always have. Crayons in the tin box were my favorite toys as a kid. As I grew older, I kept a journal of sorts, in a rather hit-or-miss fashion.

I thought it was a good idea, but did not really have much of an idea of the possibilities. And, I was private about my drawing. Sure wouldn't want to do it in public. I was afraid of attracting attention to what it was I was doing. God forbid that a stranger should see. They might ask questions.

Then, as an adult, I went off to France with Mari. Many things are different in other countries. The attitude toward art and artists is very different in both France and Mexico. Little by little, I became more comfortable drawing out in public. Right out where those strangers might see. I went from feeling comfortable drawing to feeling uncomfortable without my sketchbook. What a transition!

Now, it not only feels natural, but necessary. Recently, I was without my sketchbook for only a day, and I felt just a slight bit anxious and uncomfortable. Since the workshops, I carry a sketchbook everywhere I go and record, not only my travels, but also my daily life. Pencil and pens and crayons and watercolors, I use them right out in public!

Carol Chapel

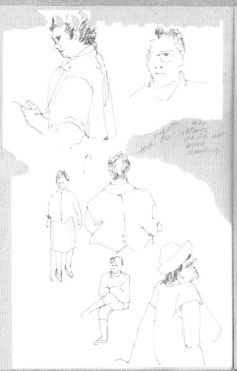
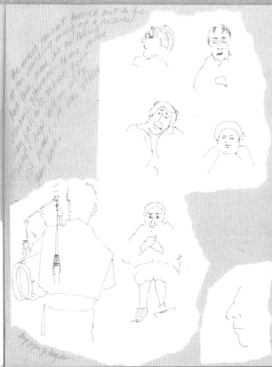

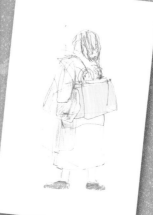

Brittany, France 2004

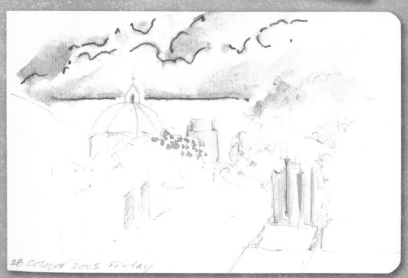

Oaxaca, Mexico 2005

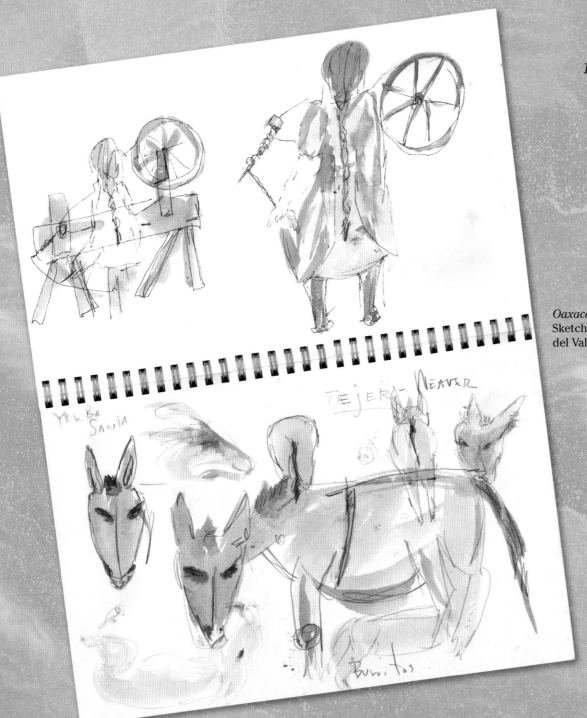

*To relax into a sketchbook
Is similar to lying in a hammock.
Everything significant is present.
Your eyes see and translate
Through the hands.
No judgment...
Like taking a nap!*

Barb Campbell

Oaxaca, Mexico
Sketches done at Teotitlan
del Valle by Barb Campbell

Mexico, 2004
Sketch of Barb Campbell by Joan Elizabeth Reid

I am a writer. I use words to capture scenes on paper. And then I play with the words, editing and rewriting them until I think there's a chance that the reader can see what I saw — or something close.

I carried that mindset into my approach to sketching. When I went shopping for supplies my first investment was a big eraser. With my lack of skill and experience, I wasn't going to get anything right the first time.

Mari's admonition to relax and let my hand follow the lines of the building fell on deaf ears. I gripped my pencil tighter and then reached for my eraser. "Here, try my pen!" Mari suggested.

It turned out that there was magic in that pen! As my eye followed the contours of the castle, the pen glided over the paper. Trees sprouted up in the foreground. I discovered that my drawing didn't need to be exact to be pleasing.

Margaret Anderson

Summer, Lake Oregon

*Provence,
France
1995*

Mari's Pen

Scribble drawing of tile roofs.

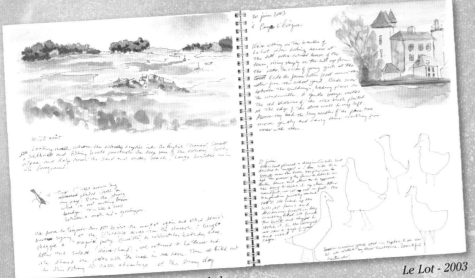

Brittany - 2002 - Last days of the workshop

Le Lot - 2003

Each sketching trip in France was a dream come true for me and I wanted to remember everything I saw. Mari quietly encouraged us to slow down, take time to observe our surroundings, and capture simple images and personal thoughts in our sketchbooks.

To help me focus and relax, I liked Mari's suggestion of starting with contour drawings and quick gesture drawings. This approach lets you connect directly with your subject matter through quiet observation and helps you forget about what your sketch should look like. After all, you are creating your own unique personal interpretation, which will not be measured or evaluated against any standard.

Barbara Folawn

2002, Brittany, France

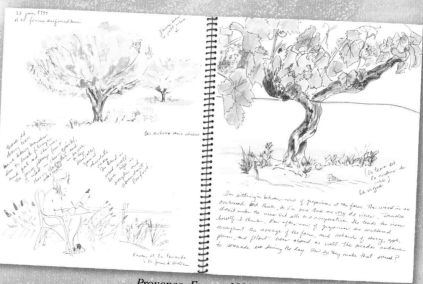

Seattle, Washington

Provence, France 1999
First time sketching

Provence, France 1999

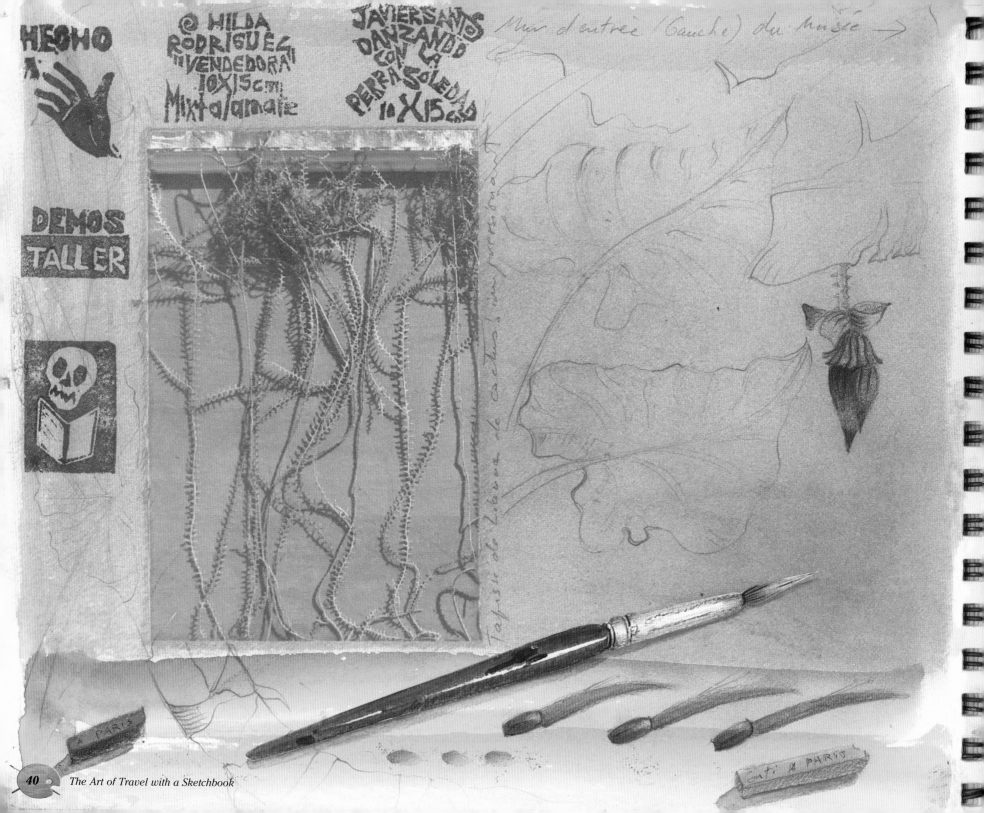

HECHO A:

@ HILDA
RODRIGUEG
"VENDEDORA"
10X15 cm
Mixta/amate

JAVIERSANTOS
DANZANDO
CON LA
PERRA SOLEDAD
10 X 15 cm

Mur d'entrée (Gauche) du musée →

DEMOS
TALLER

PARIS

Play
With
Color

Play with Color and Texture!

In the spring of 1995, I held my first sketching workshop in Provence. Since sketching is essentially simple, limiting us to one pen and one sketchbook had to be part of the approach. Everyone agreed and happily filled their pages with black and white sketches.

The following year I was back in France for a second workshop. When I suggested the use of a single pencil, I could feel some resentment. It seemed like a punishment for the "painters" in the group to be deprived of using colors. After all, we were in the heart of Provence where red and ochre pigments are everywhere you look. I found myself experiencing the same frustration as my participants and asking myself how we could incorporate this new dimension without hurting the approach. A couple of days into the workshop, I broke the "rule" and colors were added to our supply list. The artists in the group embraced the change, and others like me jumped into the new adventure and explored.

Roussillon, Provence
10" x 10" watercolor & color pencil

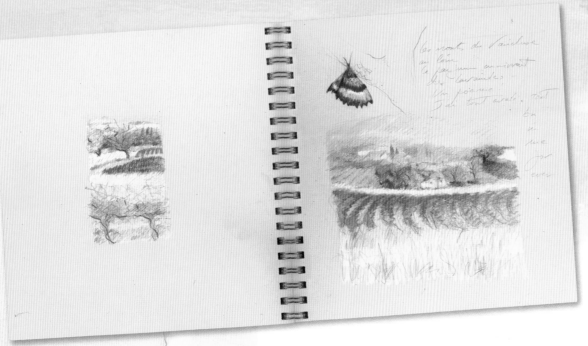

Lavender Fields…

10" x 10" color pencil

In the heat of June
The scent
The color
I drink it all
In me forever

From that day on, sketching no longer meant just drawing with one pen or pencil, but rather using anything that comes to your hand, as long as you are recording what you see in a spontaneous manner.

I still find myself favoring lines. Drawing has always been my companion, reliable and predictable. I love the sound of my pen dancing on the page, the freedom in the gesture, the simplicity and the energy of the lines. But discovering color was like making a new friend, a fun one. When I use color, I play! I am totally open; I welcome the unknown. I don't care if my pages buckle because there is too much water in my brush; I love the wrong color! I have no desire to become a painter or to master techniques. I am afraid of having expectations as how to apply colors the "right" way, of losing my spontaneity and sense of playfulness in the process.

At first, I used color pencils timidly, as they were closer to drawing. Then I discovered watercolor pencils, and I liked having the option of adding water to the pigment; it leaves room for the unexpected. Then I quickly discovered that watercolor works faster than color pencils.

On a sketch walk, six basic colors seem to be enough to play with. Like a wash, dry pastel can also cover a good portion of your page. In a second you can shift the energy, but it has the inconvenience of smearing. You may want to carry a fixative along or buy a hairspray when you reach your destination. I intentionally leave some pastel pages unsprayed. I like the ephemeral side of soft pastel, the unpredictability. I like to let colors and pages fade into each other.

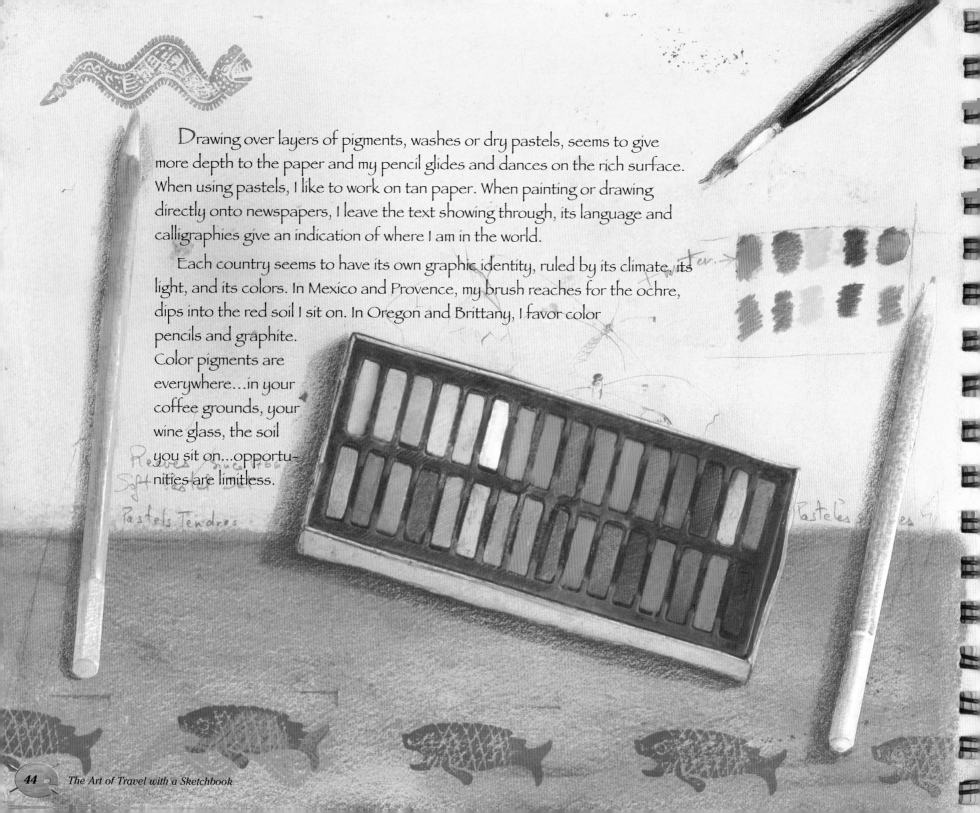

Drawing over layers of pigments, washes or dry pastels, seems to give more depth to the paper and my pencil glides and dances on the rich surface. When using pastels, I like to work on tan paper. When painting or drawing directly onto newspapers, I leave the text showing through, its language and calligraphies give an indication of where I am in the world.

Each country seems to have its own graphic identity, ruled by its climate, its light, and its colors. In Mexico and Provence, my brush reaches for the ochre, dips into the red soil I sit on. In Oregon and Brittany, I favor color pencils and graphite. Color pigments are everywhere…in your coffee grounds, your wine glass, the soil you sit on…opportunities are limitless.

Every morning before I go on my sketching day, I spread washes onto a few pages, like a ritual, a meditation. My mind is perfectly quiet. My hand takes over; my brush dips into the watercolor cakes and goes around the page quickly, in one breath. It is my conditioning, my dance before my sketching day.

Any color my hand chooses somehow fits with whatever happens during the day, like magic!

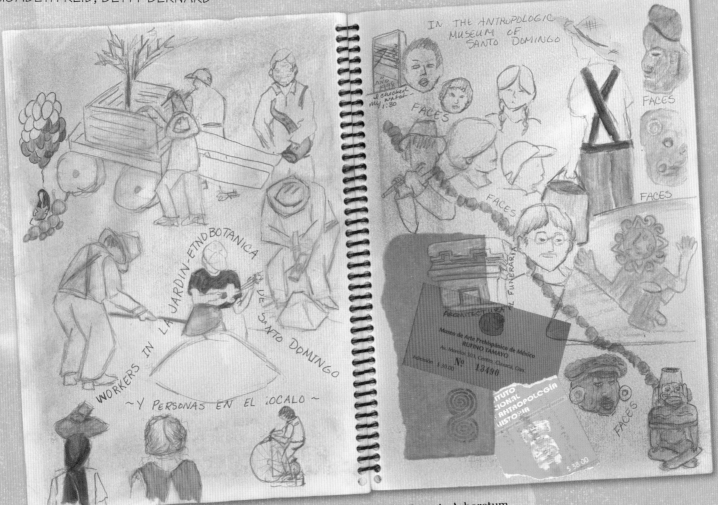

From the balcony of *Santo Domingo*, Sketches of gardeners in the Ethno-Botanic Arboretum

*I*t took the warm air of Oaxaca to put bold splashes of color into my sketchbook. Heat invited oranges, reds, yellows, and the intense purple-blue of the sky. Daily washes became more intense, my sketching more dramatic.

Color, more than shape, became my interest. Then, as I leaf through my sketchbook pages at home in the grey Oregon winter, it is the warmth of colors that takes me back to Oaxaca.

Sitting on a hillside overlooking Roussillon, in the south of France, I breathed in the rich ochre of the village. The reds, oranges, yellows, and golds mirrored the cliffs at my back. How could I mix just the right color to fill my page with this beautiful scene? Looking at the blank page, my eye traveled to the dirt at my feet. That was it!

I filled my brush with water and swirled it on the ground. The grit swished across my page. Some strokes were translucent, others more opaque. Where the grit stuck to the page, the color intensified. It was the very color and texture that builders throughout history have used to make these houses.

The water buckled the paper. It took patience to wait for the page to dry enough for my sketching to begin. Glancing around, my eyes fell on a young boy who had watched me paint with dirt. His eyes were large with wonder and his expression told me he thought I was a bit crazy.

I lifted my brush in a friendly salute, forcing a glorious grin to light his face. Maybe, someday, as he fills his own brush with the colors of the earth, he will remember the crazy lady who painted with dirt.

Dianne Roth

Dianne sketching in *Oaxaca, Mexico*

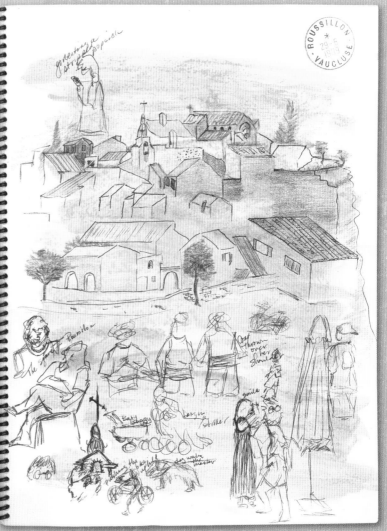

Roussillon, Provence, France 1998

The Art of Travel with a Sketchbook

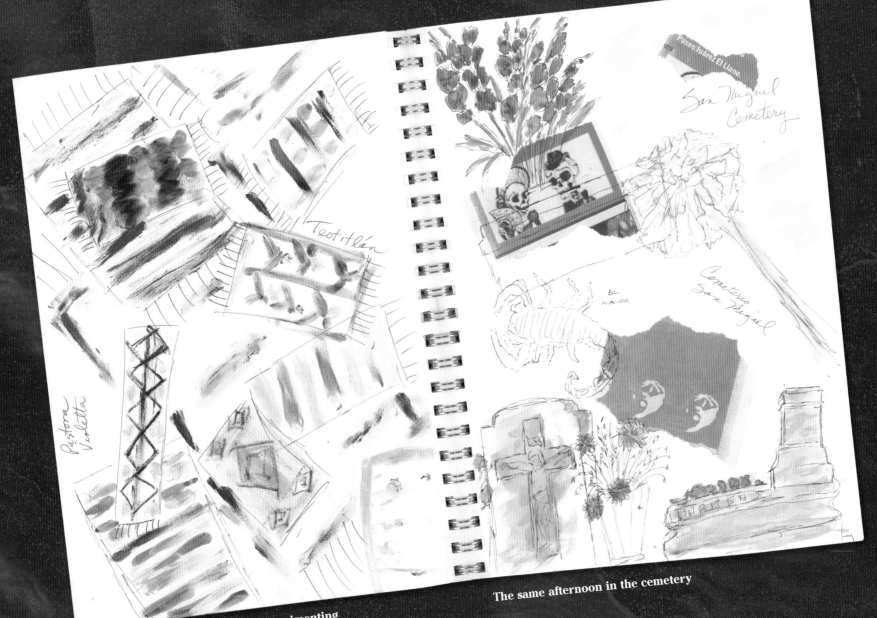

Paseo Juárez El Llano

San Miguel Cemetery

Teotitlán

Pastora Violetta

EL ALACRAN

Cementerio San Miguel

A day in *Teotitlan, Mexico, 2005* Experimenting with cochinilla dye

The same afternoon in the cemetery

cochineal

cochineal

cochineal

indigo

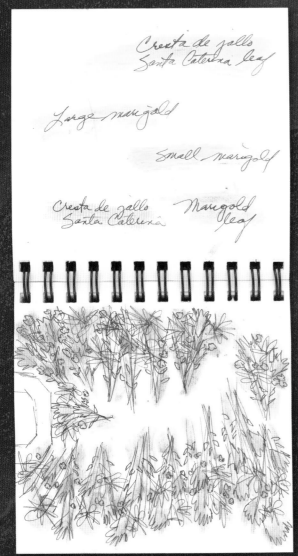

Cresta de gallo
Santa Caterina leaf

Large marigold

Small marigold

Cresta de gallo Marigold
Santa Caterina leaf

*D*uring *El Dia de los Muertos,* there were flowers everywhere…in the markets, on street corners, in the cemeteries and courtyards, bright marigolds and dark pink cresto de gallo! One afternoon, in the courtyard at la Casa Arnel, the staff members were separating piles of these flowers into bouquets and arranging them on the ground.

I sat on the doorstep of the tiny library and started quickly sketching the scene. Benita brought me some of the flowers and I used the petals and leaves to color my drawing. Although the colors of the flowers were much brighter than the sketch shows, "painting "with the flowers themselves fit with the spontaneity of the moment and when I look at my pages, I see the deep color and brightness.

Sandy Segna

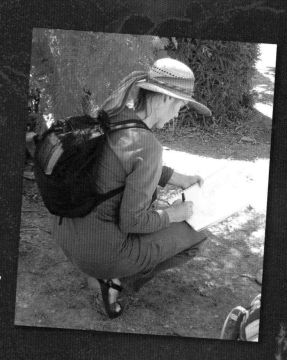

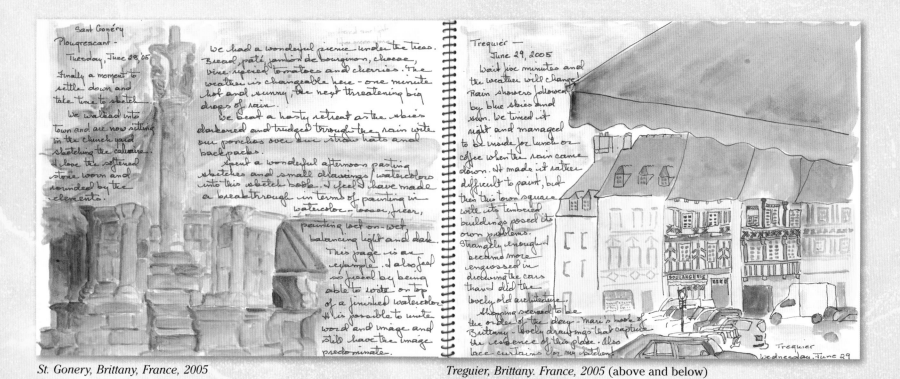

St. Gonery, Brittany, France, 2005

Treguier, Brittany. France, 2005 (above and below)

*T*raveling with a sketchbook is about having the time to go more slowly, to stop and really see what one is looking at. Perhaps one sees less "sights" than the regular traveler, but one sees more intensely and in greater detail. Morning light over an estuary, lichen-covered sculptural figures of a French calvaire comes to life on the pages of one's sketchbook.

One slows down and gains more facility with pen, colored pencil, pastel and/or watercolor as well as with subject matter.

Joan Elisabeth Reid

Joan Elisabeth Reid sketching.

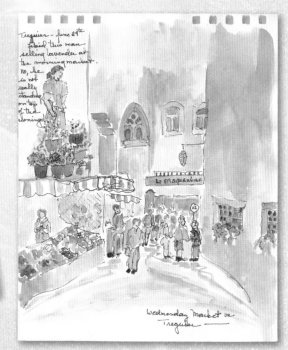

The Art of Travel with a Sketchbook

I think some places just lend themselves to certain media, and Oaxaca was no different. The wonderful colors, the earthiness, the texture were made for pastels. The first day of the workshop, Mari showed us a small art supply store, and of course, we could not resist. In the display cabinet were small sets of pastels, the colors were the same as Oaxaca—browns, oranges, lavenders, sage greens—a must have.

I personally have come to love pastel and mix media. The possibilities are limitless. You can sketch with pencil, acrylic and felt pens on top of pastel. My favorite is to stamp over the pastels. One day, I got brave and misted water onto the pages leaving wonderful texture. Since I had no fixative, I sprayed the pages with hairspray. Finely misted pages, then more pastel, then more hairspray, this builds up wonderful layers of color.

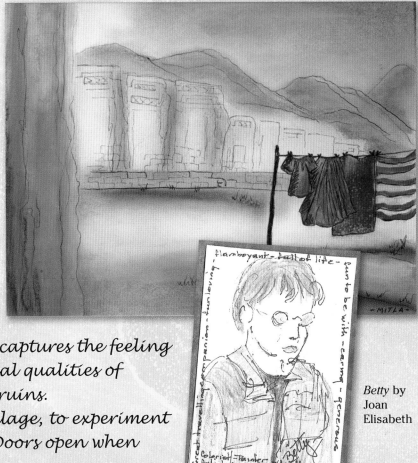

Mitla, Mexico, 2004

Betty by Joan Elisabeth

The red wall of Mitla is overexaggerated, but captures the feeling of being among ruins from long ago. The mystical qualities of Oaxaca are joined with the laundry day in the ruins.

While traveling, I have learned to play, to collage, to experiment based on what's available in the surrounding. Doors open when "traveling with a sketchbook in hand".

Betty Bernard

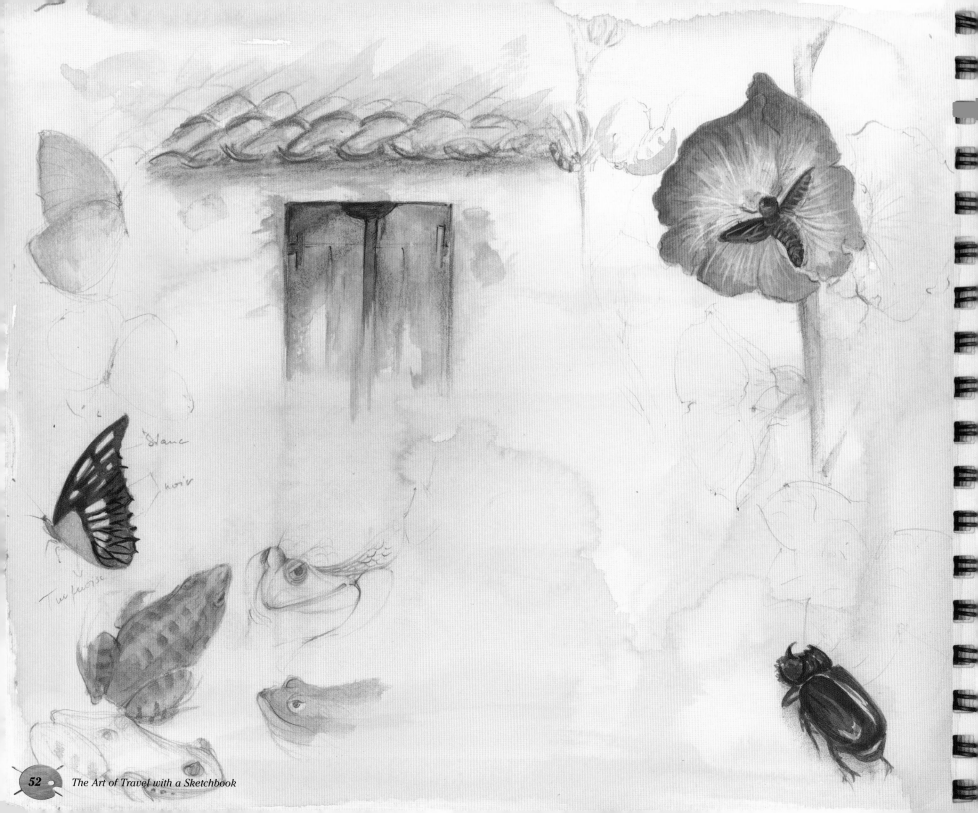

Blanc

Noir

Turquoise

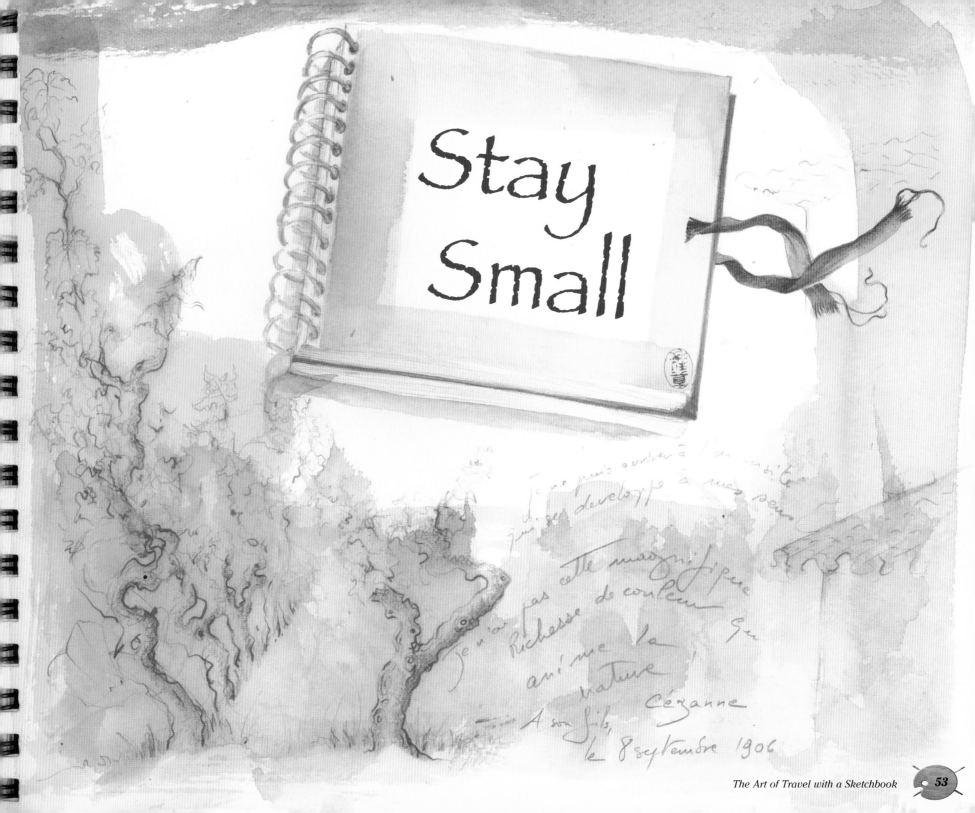

Do small vignettes,

While traveling, you find yourselves surrounded by new sights, new scents, new sensations. There is suddenly a lot of stimulation around you and you don't know where to start! My advice is to stay small. By staying "small" I mean: don't fill your whole page with one scene or one subject.

Whenever you feel overwhelmed by the vastness of a landscape and do not know where to start, pretend to be looking through a camera lens and, with a pen or pencil, trace a quick frame on your page with the general orientation, vertical or horizontal.

Sitting on the beach….the tide is coming up
10" x 10" watercolor pencils on tan paper

Brittany, France
The light, the colors, the feel are changing every second. I do not think while my hand grabs the colors that lay on the sand next to me…

Do not worry about staying within the lines. They are just there to help you focus.

Take visual notes…
10" x 10" watercolor, collage, & color pencils on tan paper

A wonderful afternoon walking in the "chemin des douanniers" in *Plougrescant, Brittany*, I sit here and there to sketch my day…

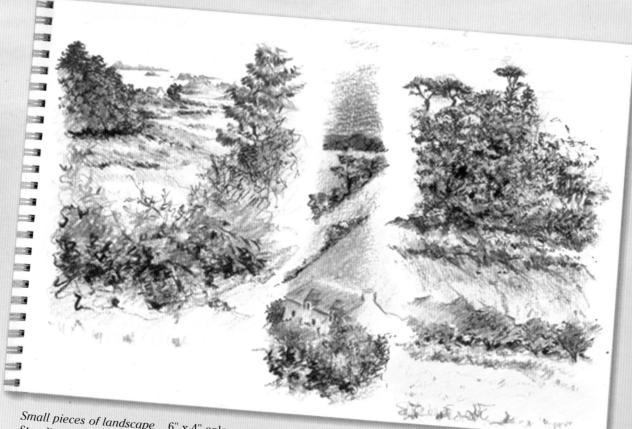

Small pieces of landscape 6" x 4" color pencils & black pen

Standing above the estuary at "La Roche Jaune" on the north coast of Brittany. It is so spectacular! The tide is swelling the river, l'ile d'Er in the distance, the deep green chestnuts down below, the golden wheat fields in the foreground. Tracing three small vertical frames is the only way that I could say it all. Every time I look at this page, I see colors and shapes in the whites between the frames.

Unless you use your pocket size sketchbook, filling your page with one subject will tempt you to compose and anticipate. Often it is enough to suggest the corner of a window, or a small piece of sky. The whole flavor will be there, in your sketchbook and in your memory.

I advise my participants to walk here and there, without agenda, and sketch anything that catches their eye, spontaneously and randomly. Your page will reflect what you have seen and experienced, each page telling a story and becoming a patchwork of memories.

I always find it exciting not knowing what will be sitting on a page at the end of the day.

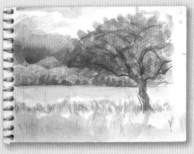

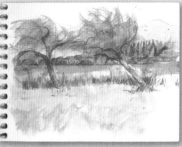

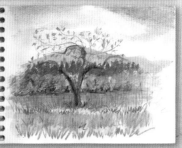

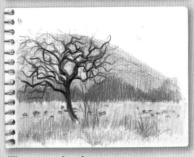

The same landscape…
but, never the same!

3½" x 4¾" watercolor, color pencils & pencil

My pocket sketchbook allows me to fill a whole page in a very short time. Above, Mary's Peak in the distance at four different seasons, never the same…

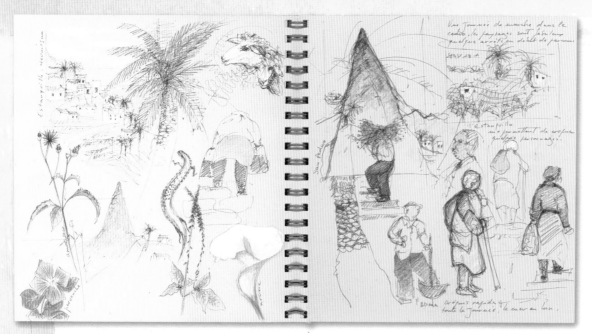

Sketch walk...

I encourage my participants to sketch when walking, to have their small sketchbook in one hand and a pen in the other. Walk slowly, stop here and there, stand still for a few seconds and be aware of what surrounds you, the sounds, the scents, the colors.

Your eye has caught something, a leaf, the light on a tree, a rabbit crossing the path...lay quick lines or brush strokes and move on.

Keep in mind "contour" to sketch that leaf, and gesture for the bird flying over your head, record as much as you can. Write quick notes about details.

Ultimately, sketch walking will help you develop your photographic memory. One glance and you will remember everything about that moment.

Sketch walking in La Gomera

10" x 10" black pen, color pencil

A day hiking on the "Cedro". A few quick stops here and there allow me to add colors...

Observe, listen, record...

9" x 12" watercolor & pencil

Playa Zancudo, Costa Rica
Sitting under the shade of a coconut tree on the beach. I sketch what I see, what I hear, what I smell...

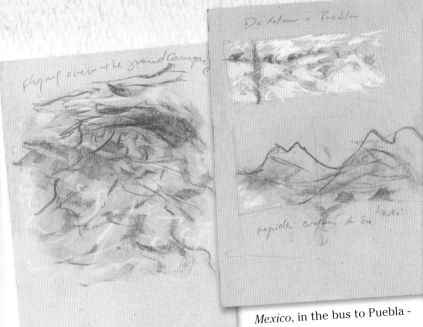

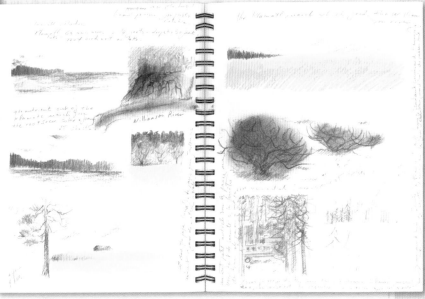

Mexico, in the bus to Puebla - pastels

Portland to San Diego, in the train - pastels & pencil

Mexico, flying over the Sierra Madre - pastels

Make it a habit to have your favorite pen and your sketchbook with you all the time. Waiting for a train, a bus, try to sketch everywhere. Time will fly. Even a delay will be welcome!

On horseback in *Costa Rica* - watercolor & pencil

Mexico, in the bus to Puerto Angel - watercolor & Micron

Costa Rica, canoe ride on the river - watercolor & pencil

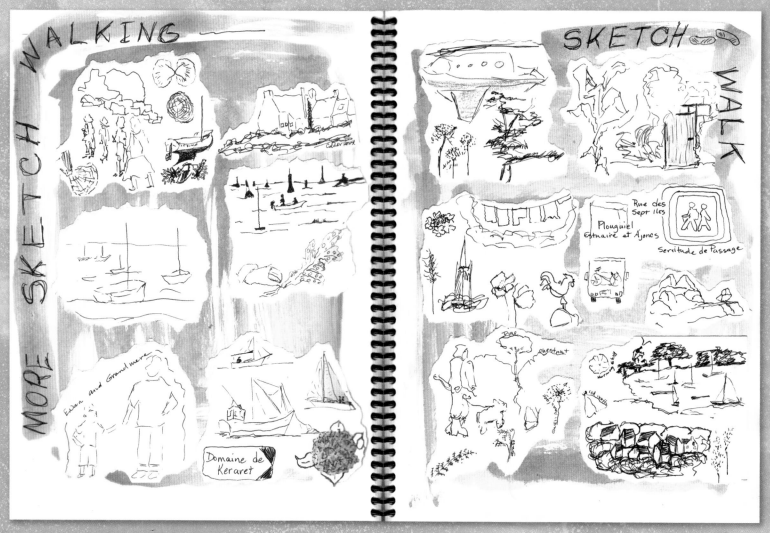

On our first day at the workshop in Brittany, Mari introduced us to the basics of contour and gesture drawing. With nothing more than our pocket sketchbooks and a favorite pen, she led us along the estuary to practice our new skills. What seemed impossible became a meditation.

Quick lines captured boats, church spires, laundry, and locals meandering through their daily lives. Those small pages torn and glued into my large sketchbook make a dramatic record of the quick walk around the estuary and through the countryside of Brittany, France.

Dianne Roth, 2005

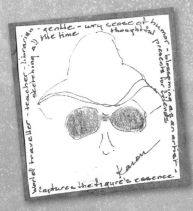

Karen
by Joan Elisabeth Reid

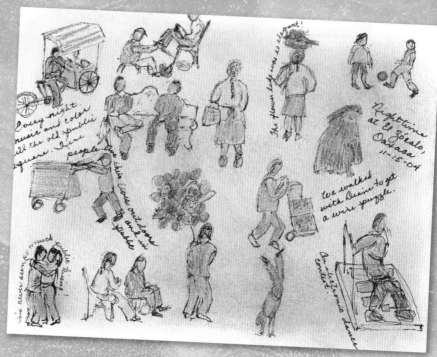

I'm a beginner at drawing, and my former journals had been filled with words, not pictures. Mari says there are no rules for sketchbook journals, so I just plunged in, trying to capture as many Oaxacan images as I could. In El Zocalo, I wanted to capture the festive feeling of the square, all the activity, and the sense of that place, so I kept my sketches small and filled the page. I still smile when I look at it.

Karen Kenyon, Mexico, 2004

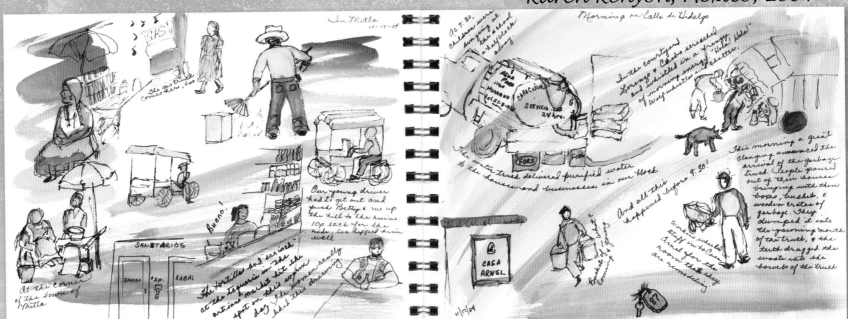

Monte Alban is such an immense and spiritually powerful place that I was overwhelmed with awe of the place. I didn't know where to start. Wandering around for a while, I finally settled on a structure that I "thought" I could draw. I found a comfortable place to sit and began sketching what appeared to be an ancient temple.

After an hour of sketching, I wasn't anywhere near finished! About this time Mari sat down beside me and gently suggested that I didn't need to include every rock and brick in my sketch! She suggested that I sketch the essence of the temple by drawing the outline of one corner. That would be all that I needed and that my mind would fill in the details when I looked at the sketch at a later time.

This was an important lesson for me. I sketched the corner of the temple in a couple of minutes and then began sketching small parts of many of the structures. At the end of the day, I did feel that I had captured the essence of Monte Alban in my sketchbook. Instead of one detailed temple, I had captured the feeling of Monte Alban.

After Monte Alban, I really began to enjoy traveling with a sketchbook and capturing the experiences on paper.

The sketch from Teotitlan is one of my favorites. The quick sketches and colors really make the experience of being in Teotitlan amongst the weavers come vividly alive in my mind when I look at that page in my sketchbook. From the beautiful cathedral in town, to Pastora's moving description of the Dios de los Muertos altar and the wonderful weavings made from natural wool...it is like I am right there in that moment again.

Ted Ernst

The upper drawing is my first attempt at sketching Monte Alban. The bottom drawing contains quick sketches that better captured the feeling and essence of Monte Alban for me.

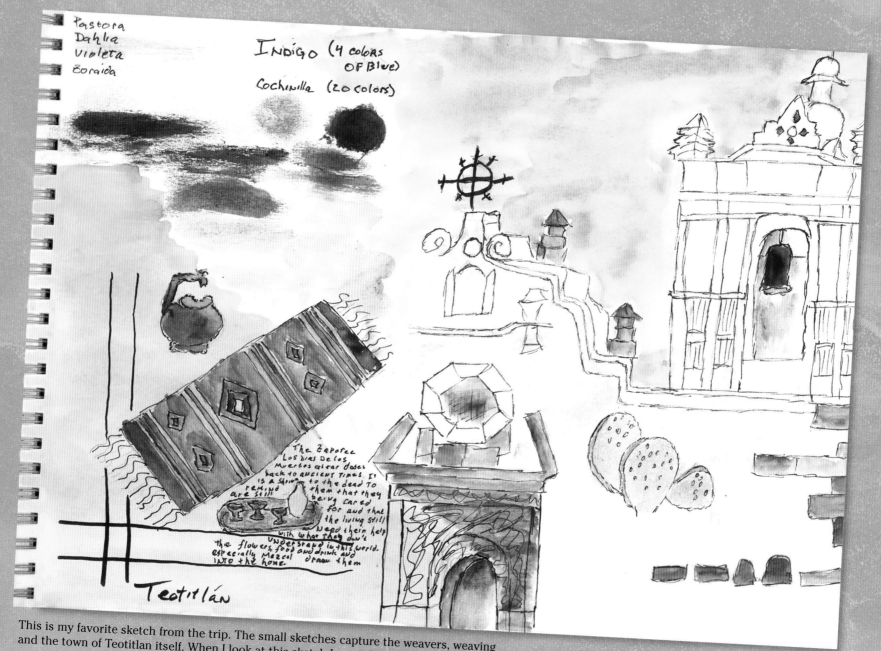

Pastora
Dahlia
Violeta
Boraida

INDIGO (4 colors OF Blue)

Cochinilla (20 colors)

The Zapotec
Los Dias De Los
Muertos altar dates
back to ancient times. It
is a show to the dead to
remind them that they
are still being cared
for and that
the living still
need their help
with what they don't
understand in this world.
the flowers, food and drink and
especially Mezcal draw them
into the home.

Teotitlán

This is my favorite sketch from the trip. The small sketches capture the weavers, weaving
and the town of Teotitlan itself. When I look at this sketch I am right back there!

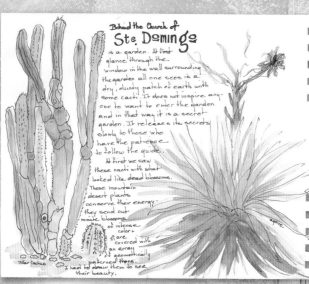

Behind the Church of
Ste. Domingo

is a garden. At first glance through the window in the wall surrounding the garden all one sees is a dry, dusty patch of earth with some cacti. It does not inspire anyone to want to enter the garden and in that way it is a secret garden. It releases its secrets slowly to those who have the patience to follow the guide.

At first we saw these cacti with what looked like dead blossoms. These mountain desert plants conserve their energy—they send out minute blossoms of intense color & are covered with an array of geometrically patterned thorns. I had to draw them to see their beauty.

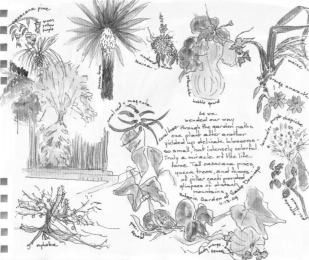

As we wended our way through the garden paths one plant after another yielded up delicate blossoms—so small, but intensely colorful! Truly a miracle of the life force. Tall oaxacana pines, yucca trees, and fences of pillar cacti provided glimpses of distant mountains. Botanic Garden of Santo Domingo 11-18-04

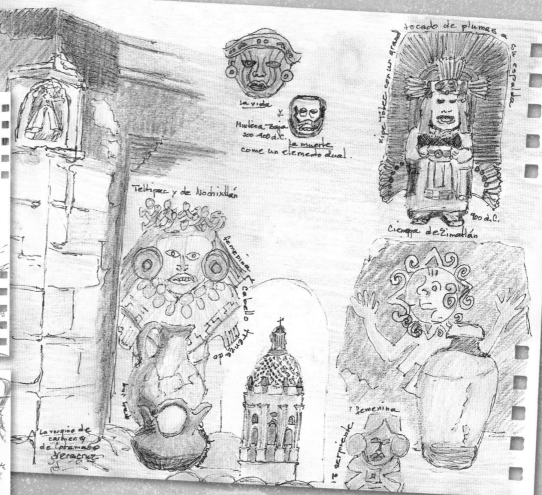

*T*raveling with a sketchbook, one is lost in one's subject; the hand moves of its own accord, mental chatter recedes, and time slows. Small garden flowers, a woman going to church, people at a busy Sunday market, ancient Zapotec palace ruins. Everything seems to come into place.

Joan Elisabeth Reid

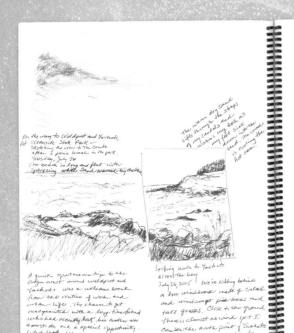

Oregon, 2005

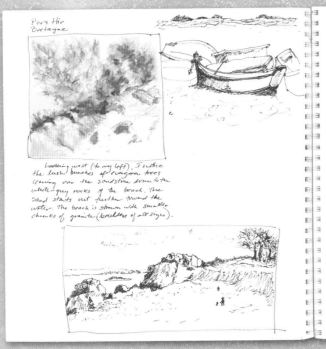

Brittany, 2002

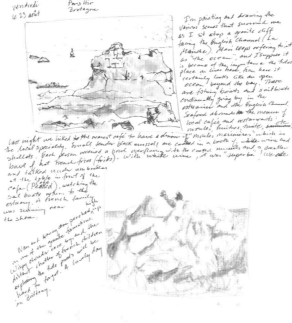

Mari suggests "staying small" when beginning to observe our world and capture it through sketches. To me, this means looking through a small window to select a pleasing shape or a special memory that I want to take away with me.

To help limit my scope, I often draw the outline of a window on part of my page. The small sketch captures the moment, then I move on.

Barbara Folawn

Le lendemain du marché au fleur / au cimetière, el Panthéon, rempli de

Jour et nuit inoubliables! les cloches ... veront jusq... 3-4 demain.

... tout les Arbres au mouli... à ... on ne prépare pour le chocolat chaud. inoublie el atolle

Día de muertos
Ofrenda para los difuntos

LUNES • 1° • NOVIEMBRE • 2004

ARCHI...

■ MIRNA SERVÍN VEGA

Convivir con cadáveres y sus restos, sacarlos de las fosas, meter los siguientes, rascar con pico y pala la tierra, además del resto del trabajo que se realiza en un panteón, son las labores cotidianas de las hermanas Emelia y Guadalupe Morales Contreras, y de Isabel Ramos Mora, *Las Camilitas* de la delegación Alvaro Obregón, quienes desde hace 22 años son sepultureras en el panteón San Rafael.

De acuerdo con José Trinidad Lima Gallardo, titular de la Unidad de Panteones de Alvaro Obregón, son las únicas sepultureras en todo México de las que se tiene conocimiento.

Debido a que las mujeres son de edad mayor y el trabajo que realizan es difícil, en diversas ocasiones se les ha propuesto cambiarlas a otro tipo de actividad más ligera, ante lo cual han respondido con énfasis que no cambiarían su trabajo, pues ellas quieren conservar y hacer su lugar de trabajo en este panteón, señaló el funcionario.

Con los años, estas tres mujeres se han convertido en abuelas, pero cuando llegaron a trabajar al panteón San Rafael, apenas habían concebido a sus hijos, a los que había que mantener y dar educación. Todo salió de su trabajo de sepultureras, a pesar de que su sueldo es poco, pero, según cuentan, suficiente para el

sustento familiar, e incluso una e... ción superior para sus hijos, qu... actualmente son profesionistas.

De esta manera, Emelia, Guadal... Isabel, cuyas edades oscilan entre los... 58 años de edad, desde hace 22 añ... dedican a la ardua labor de sepulture... este panteón, ubicado en Revolución... 10 San Jerónimo, en la zona de San A...

Ellas relatan que se iniciaron real... do labores en intensas jornadas pa... introducción de servicios en su co... después llegaron como voluntarias a... teón San Rafael, en 1982, hasta que... mente fueron contratadas por la d... ción Alvaro Obregón, debido a la c... de su trabajo, mostrado desde enton... mismo empeño y dedicación a pes... ser un trabajo exclusivo para varon...

El trabajo de sepulturero no es pa... la gente debido al contacto cotidiano co... restos humanos que tiene que mane... como por el esfuerzo físico que se re...

En el caso de estas tres m... comenta el funcionario, su labor e... meticulosa y compiten al ciento po... to con los hombres, además d... muchas veces han tenido que enfre... con roca volcánica de dimensiones... derables y con losas cuyo peso... entre los 200 kilogramos, por lo qu... se las han ingeniado para salir ad... con este pesado empleo.

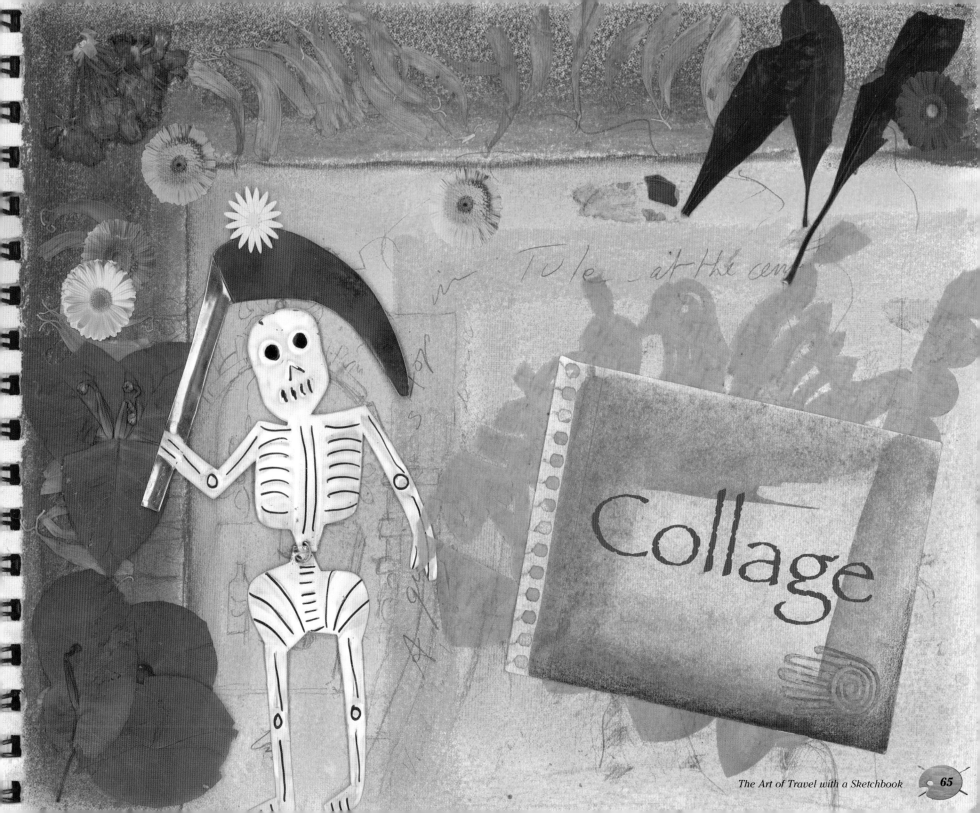

Collage

Collect, Tear, Glue...

Collecting, assembling, and gluing have to be the most playful parts of a travel sketchbook. It is so simple! All you need is a sketchbook, a glue stick, and the awareness of those little, recyclable treasures you find along the way. Before you leave on a trip, you can glue a map of where you are going on either the cover or the first page. Then add your plane, train, or bus ticket stub or your boarding pass. When you have reached your destination, buy a local newspaper, tear off part of a page and glue it in your sketchbook. The energy of the page will change instantly and inspire you to glue in some more found objects, or even paint or draw over it. Wander through the nearby market; pick up anything that catches your eye, anything that would otherwise be thrown into the garbage or washed down a drain. Gather seeds, peels, spices, stamps, labels, receipts'...even shells, buttons, coins; allow your sketchbook to become three-dimensional!

A sketchbook is a place where your photos can take on a new dimension! After you glue them on, frame them with a few strokes or with some tape. Regular masking tape can be colored with pastels or paints; play!

Tip: I sometimes scan a photograph of a door or window (see page 14). I enlarge the photo, print it in black and white, and color it in. It is a fun process!

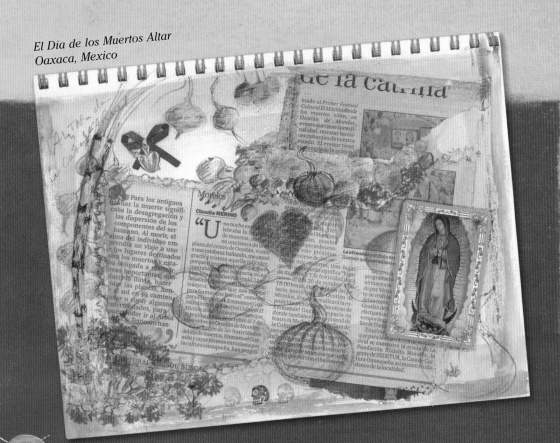

El Dia de los Muertos Altar
Oaxaca, Mexico

"The night has covered Oaxaca. It is quiet on the patio. Domingo, who is sitting at the end of the table, has given me permission to draw him. It is a privilege. All I have is a paper bag and a couple of colored pencils. I sit in front of him and start sketching. My pencil moves, inside and around his beautiful features. Soon, there is only Domingo and my pencil. I feel his serious gaze on my hand. I lose track of time.

Later that night, I tore Domingo's portrait with my fingers to glue it against an ochre wall and into my sketchbook, where he belongs."

du 14 au 30 juillet 2006

En Provence, l'art de vivre en musique

In no time you will transform a white page into a fun and meaningful montage, full of color and texture. There are no rules as how your collage has to be organized or balanced. There are no limits to what you can glue in your sketchbook. No need to worry about composition, perspective or shading, you may or may not want to add graphics. The focus will no longer be on your lines, but on the whole page.

The whole process is so much fun and so creative that it has helped many people to start their sketching adventure. If it is your first time at sketching and you feel a little apprehensive about laying lines or colors on an immaculate white page,
collage will ease your first step and take the pressure off.

You will quickly find out that different papers call for different tools. Newsprint, for example, being of poor quality, will tend to tear with watercolors and inks, while color pencil and dry/oil pastel will thrive on its surface. Again, I welcome the tears like I welcome the wrong color. Somehow, a torn piece of paper will find its place and purpose on a page. Explore!

If you are an experienced artist and have never played with collage, this new medium will force you out of your predictable "good" and "beautiful" pages, opening a new window to creativity. In collage, the ordinary becomes extraordinary and brings the child out of everyone!

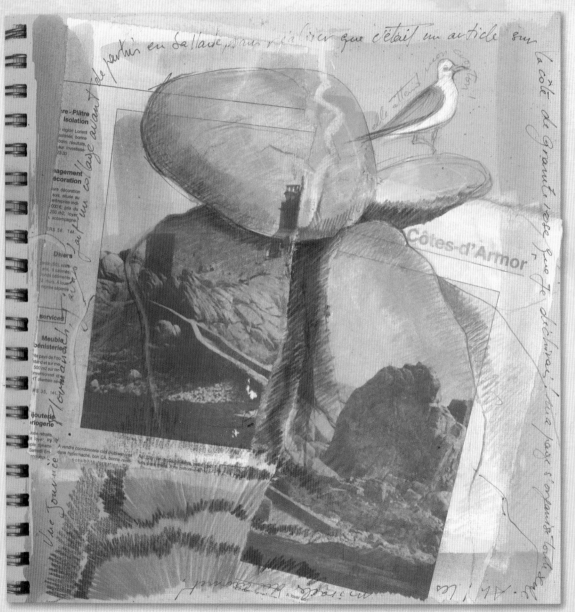

Just go with the flow… whatever comes…
10" x 10" collage & watercolor

As a demo on collage, in Brittany, I tore a page from a local newspaper, glued some of it onto my sketchbook, and spread a wash. That same afternoon, we went to Ploumanach on the Côte de Granite Rose. I drew more pink boulders on top of the collage, adding to the powerful feel of the place.

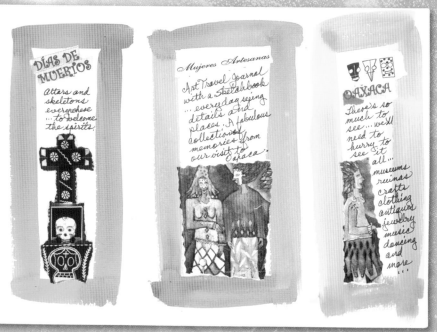

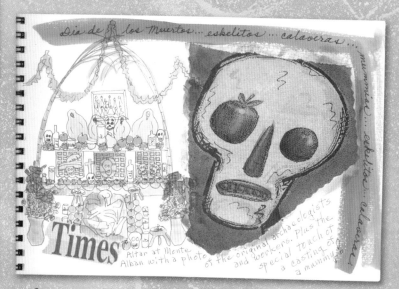

I love to add interest and texture to my sketchbook with newspaper clippings, local brochures, leaves, pressed flowers... well just about any and everything decorative and flat enough to fit in my book .

I always have a glue stick handy, ready to pick up or tear out an image and paste it right on the page. It is easy to draw or write around the little treasure.

Mari suggested painting a simple color band on pages, or tearing a strip of colored paper as a border. Her great idea highlights any drawing and adds interest.

Suzanne McNeill

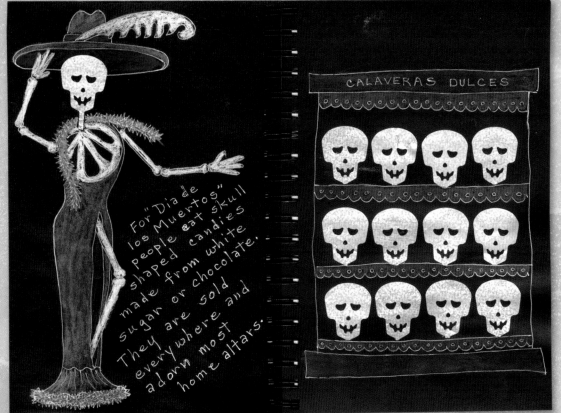

For "Dia de los Muertos" people eat skull shaped candies made from white sugar or chocolate. They are sold everywhere and adorn most home altars.

CALAVERAS DULCES

'Day of the Dead' traditions in *Oaxaca, Mexico, 2005*

People are often the highlight of each day. After I added a banana leaf and tickets to the page below, each vendor wanted me to include a drawing of them in my sketchbook so I 'tried'. The sketches may not actually look like portraits of the people, but I really remember their dress., hats, and friendly personalities ...plus it was great fun!

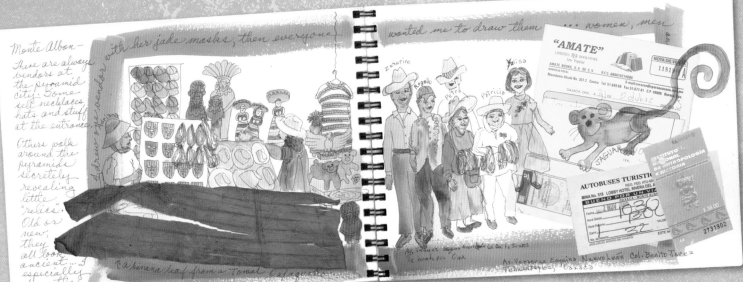

Monte Alban—
There are always vendors at the pyramid city. Some sell necklaces, hats and stuff at the entrance.

Others walk around the pyramids secretely revealing little "relics". Old or new, they all look ancient ...I especially love the jaguars.

I draw one vendor with her jade masks, then everyone wanted me to draw them ... women, men

A banana leaf from a Tamal Oaxaqueño

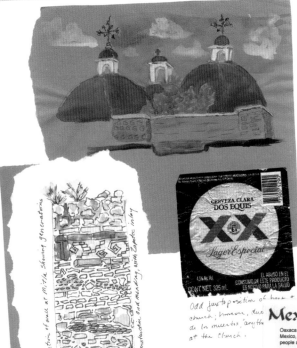

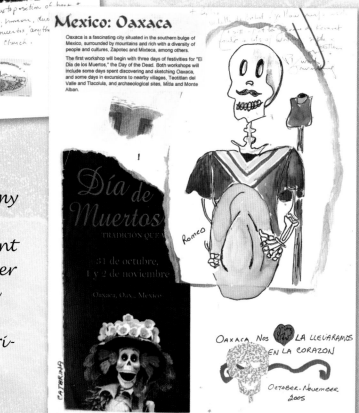

Skeletons are everywhere in every shape + form. Dressed as dators nurses large busted women, playing pianos, hugging children, carved into paper cut outs and hanging in doorways.

Section of wall at Mitla showing generations of construction and merging with Zapotec inlay

Odd juxtaposition of hose + church; however, during de los muertos 'anything' at the church.

Mexico: Oaxaca

Oaxaca is a fascinating city situated in the southern bulge of Mexico, surrounded by mountains and rich with a diversity of people and cultures, Zapotec and Mixteca, among others.

The first workshop will begin with three days of festivities for "El Dia de los Muertos," the Day of the Dead. Both workshops will include some days spent discovering and sketching Oaxaca, and some days in excursions to nearby villages, Teotitlan del Valle and Tlacolula, and archaeological sites, Mitla and Monte Alban.

Romeo

OAXACA NOS ♥ LA LLEVARAMOS
EN LA CORAZON

OCTOBER-NOVEMBER
2005

I used to collect odds and ends of papers and pictures on my trips and have nowhere to put them. When I got home, they went into a paper bag and no one ever saw them. Now I integrate them with my sketches and then my sketchbook is rich with the experiences of my trip.

Roberta Wallace

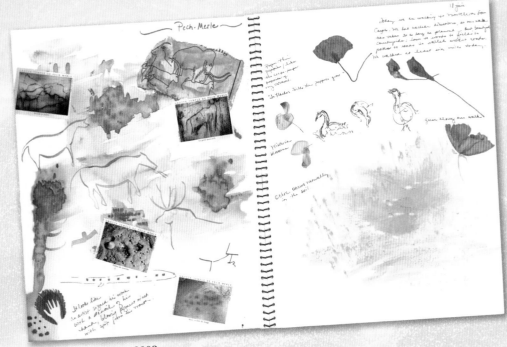

Dordogne, France, 2003

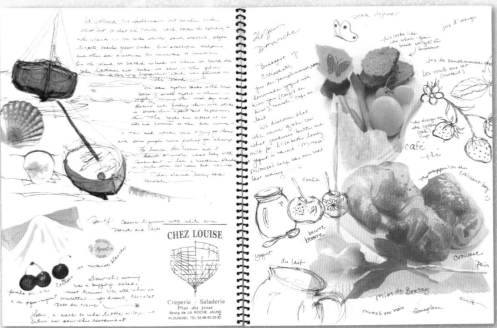

Brittany, France, 2005

In June of 1999, I joined Mari for my first sketching workshop in Provence. In the past, I had been to artist workshops and had kept journals. But, with Mari, I soon learned that this experience would be different. It would free me from expectations and allow me to relax. I was able to let the moment and the colors flow around me and onto my pages.

I have returned to France two more times, in Le Lot and Brittany. Each experience has opened me to the moment and the almost unconscious recording of it. Quick drawings with ink, splashes of color, dirt and sand, shells, and pieces of bread wrappers appeared on my pages. I played with line, color and collage as never before.

Today, when I return to my sketchbooks, I am there in the sun and heat, swatting gnats, or in the rain under my poncho, and I relive all those great moments, all over again.

Karen Kreamer

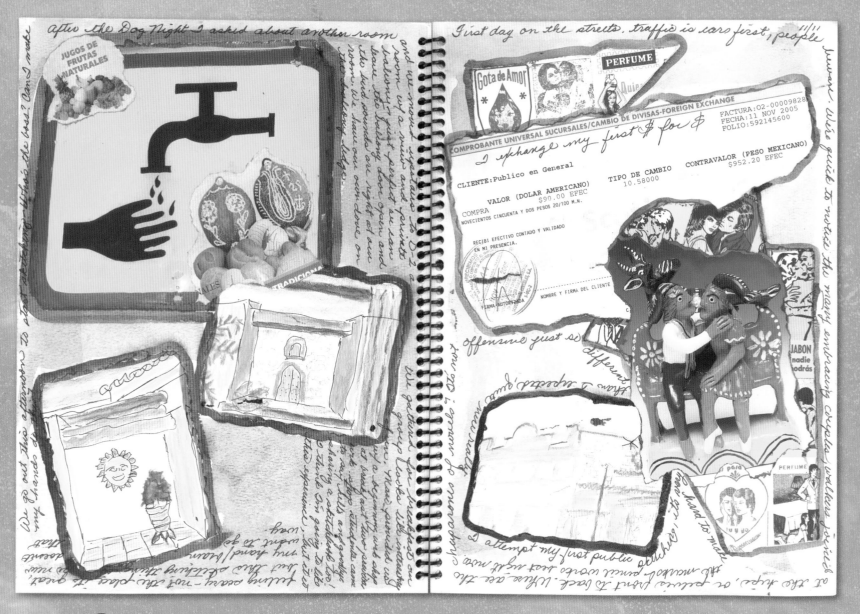

Being a very new "newbie" to sketching and watercolors, the idea of big, blank, white pages was terrifying. Although I was using a small sketchbook, my hand actually shook when I did my first attempts at sketching. I loved Mari's suggestion to put a wash on first or to mix collage and sketching/painting.

Tlacolula happened after two or three days of doing some sketching so it was less scary. I prepared the page with a wash so never saw the big, blank, white page when I sat down on the curb to sketch. I wanted to get down the numerous colors, and items for sale so I started with them.

I knew I would never have time for most of what I was seeing, so I used collage to remind me of the delicious roasting chicken smell that was everywhere, also the countless, colorful vegetables and fruit stands. Collage completes the whole Tlacolula experience for me.

With collage I could often get down an idea, in spite of there being no actual object to look at and sketch. On the couples page Mari has used (right), I wanted to convey my impressions of the numerous public lovers I saw everywhere in town and I knew I didn't draw well enough, or fast enough to sketch all the couples, even if they had been willing to let me draw them. With collage I can look at that page and, in my mind, go right back to Oaxaca and remember how surprised and delighted I was to see so many embracing couples.

Collage is a technique I've continued to use on the recent trips I've taken, I rely on it to remind me of what I didn't have time to draw or to enhance something I have drawn.

Mimi Shawe

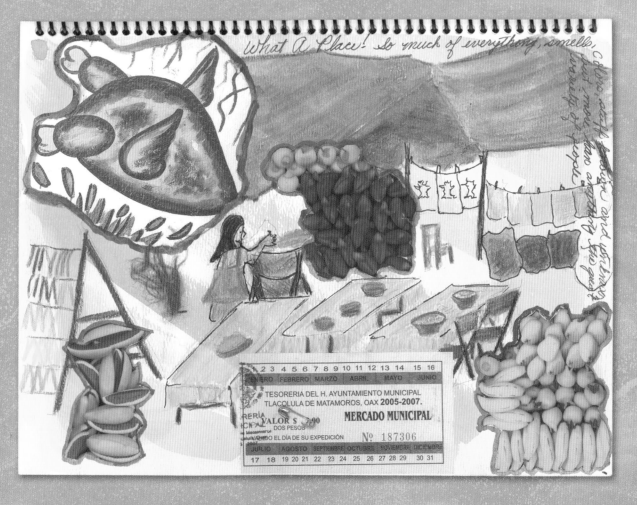

Drawing of Mimi by Prue.

Su envío de dólares llega en dólares

LAS LENGUAS INDÍGENAS SE VAN MURIENDO...

...LA MADRE INDÍGENA CUANDO A LA CIUDAD VA A TRABAJAR EN LABORES MENORES PIERDE EL PRACTICAR SU LENGUA Y AUNADO A ELLO NO SE LA ENSEÑA A SUS HIJOS POR LO QUE, EL PAÍS, ESTA PERDIENDO SU TESORO FILOLÓGICO POR OTRO LADO EL INDÍGENA YA EN LA CIUDAD SE APENA DE SU IDENTIDAD Y PREFIERE NO HABLARLA.

10% DE DESCU...
en comisiones
EN SUS ENVÍO...
pagaderos en dólares únicamente*

Válido únicamente al enviar su dinero en el sistema "Envíe Dólares, Cobre en Dólares", en envíos de más de 300 dólares.

MISCELANEA

Sketch
with
Words

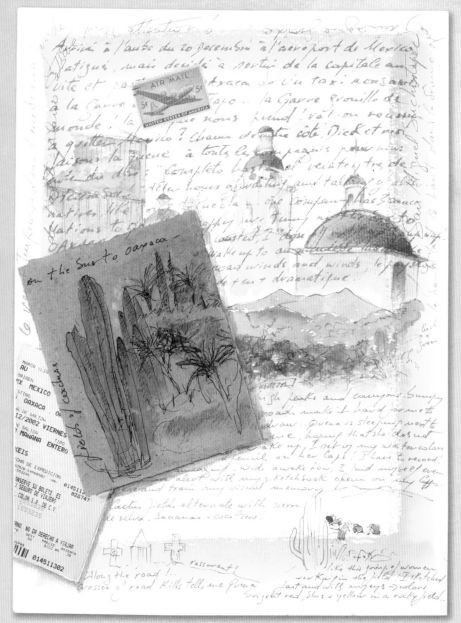

Play with words, tell stories…

Use words as you use colors and lines to describe your immediate thoughts. Welcome them as they pour onto your page. Words are just another tool to add to an image and help translate a moment or an emotion. Following your lines, words will become graphic and add movement to the rest of the page.

To me there is a difference between journaling and sketching. The French word "jour", which means "day," is embedded in the word journaling. It implies writing as a daily practice. In defining journaling, there is no mention of color or line. In "sketchbooking", you can use everything that comes to your hand; drawing, painting, collage and words. None of these tools has to be more important than the others. Words are just another graphic you can use spontaneously, without judgment. When I look at my sketchbooks, there are many pages without any words and others where I write down words as they come rushing through my hand.

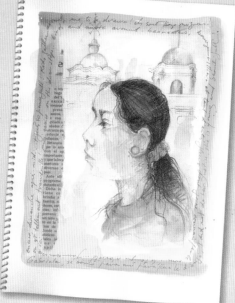

An afternoon with Gabriela in the barrio de Xochimilco, Oaxaca Mexico
9" x 12" watercolor, pencil, collage & color pencil
Gabriela poses for me, with a very serious look on her face while her brothers, sisters and cousins giggle and play around us.

Sketching in the bus
9" x 12" collage & watercolor
The ride between Mexico City and Oaxaca is bumpy, but I am determined to sketch and write about this adventure which just started yesterday. I start laying a wash on my page. Then I quickly sketch as we ride through mountains and villages. When my page is full with lines and colors, I write words as they pour through my fingers…they describe my feelings and emotions. At that point, the language I use is irrelevant…

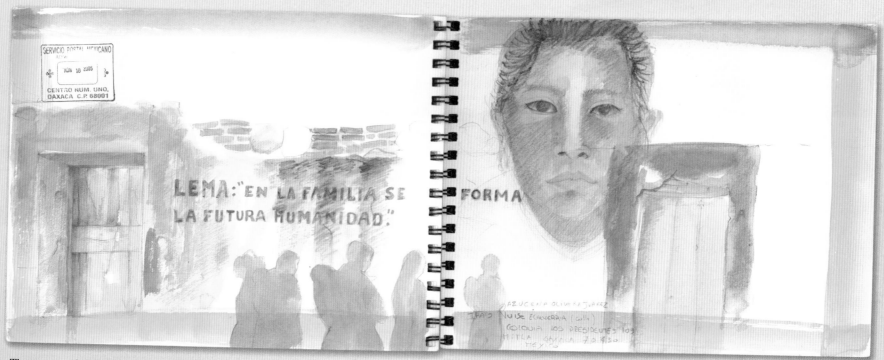

The power of words…
a wall in Mitla, Oaxaca, Mexico
9" x 12" watercolor & pencil

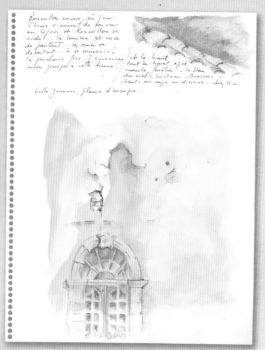

Some days you may write to recall past moments and remember ideas. Words will help your memory. Writing my thoughts helps me find my way through difficult situations. I seldom go back and read what I have written. I write only to remember how I felt at that very moment, to help me process a thought or a situation. I do not erase words, as they also are part of the emotion.

You can copy slogans or graffiti you see written on walls. Or, you can be poetic. The only times I have written poetry were in my sketchbooks, when beautiful words emerged, free, like music. Again, beauty comes through happiness; I feel no pressure, no need to be grammatically correct, no performing; I am free to write sentences without verbs or punctuation, free to use and mix languages. It is my heart that dictates my hand when I write, just like any other sketching tool. I let words simply flow through my mind and through my fingers, straight onto my sketchbook page.

Describing a sunset in Roussillon, Provence, France
9" x 12" watercolor & color pencil

Sitting on a stone wall, looking over the Place de la République. The sun is setting down over the hills leaving the wall across from me glowing pink and gold. My brush dips into the ochre and onto my page. I follow the cracks in the wall, totally aware. Chez Mimi, Brassens is singing "Je m'suis fait tout p'tit devant une poupée"…the swallows are diving over the tile roofs. Time has stopped while I drink it all!

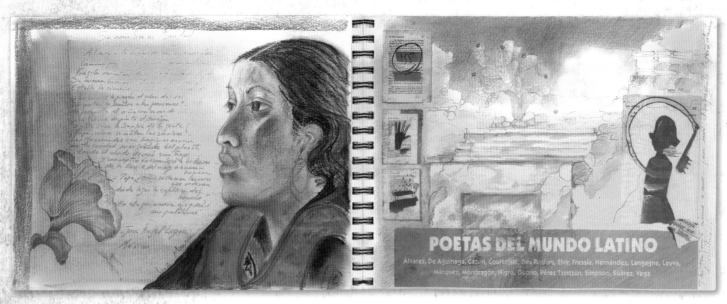

Poets of the Latino world

9" x 12" collage, gouache, pencil & watercolor

These two pages are a reminder of the wonders of sketching with no agenda or anticipation! The two pages had to be next to each other. The poem "Su nombre es Bagdad" that I copied from La Jornada, special edition on the poets of the Latino world somehow fits "Luz Maria's" portrait. On the facing page, I glued some more pieces of the same article and sat on the sidewalk to sketch a favorite window, open to the sky…

Local newspapers are always a great addition to a page. Tear and glue articles that catch your attention, let words and calligraphy come through, they will give an indication of where you are in the world.

Rubbings from coins, carved stones will instantly make a page interesting and unique. And of course, you can always ask people to write a few words in their language in your sketchbook.

Here and there…

9" x 12" collage, gouache, pencil & watercolor

Being here, in Oaxaca, Mexico enhances the amazing fact of life that at this same instant, everyone in the world is living its own reality. Today, Arafat has died. Throughout the day, I'll work over the collage I did in the morning. I just discovered how smooth a regular graphite pencil will glide over gouache. Wonderful feel!

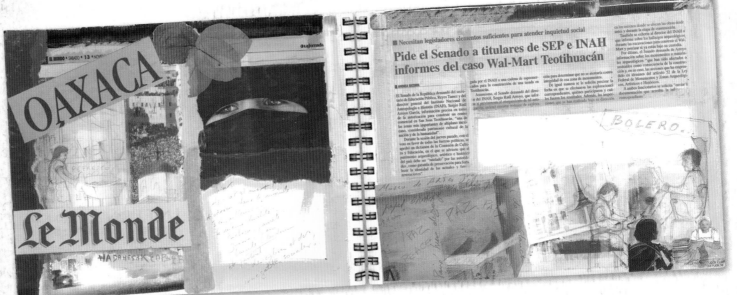

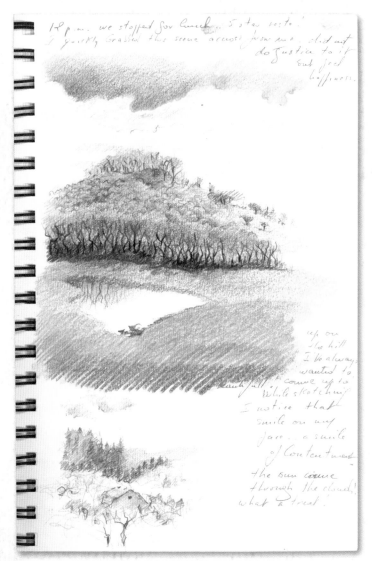

Feeling light and happy

7" x 10" color pencil & pencil

Everything about that page, the strokes, firm and spontaneous, the deep green, the black line under the tree beyond the pond reminds me how happy I was that day, sketching nature on a cold winter day in *Finley, Oregon.*

Most of the time, words sit right next to lines in my sketchbooks; they are observations and feelings. Often I use my sketchbook pages to organize, explore ideas, and plan the next step to take in my workshop.

When you are sketch walking or field sketching, you can use words as references to remember colors and other details that you would not otherwise have time to record. You can start your sketchbook page as you would a journal, with the date, time, and location. Then write details about what you hear, smell, taste or see; anything you want, you are free! Words are just another great tool we have to use and play with!

Let your thoughts and words pour out through your fingers and onto the page...

9" x 12"

In 1996, in one of my sketchbooks, I wrote... Keep your hand moving, breathe with the lines, let your pen dance onto your page...

Ten years after, those words are still accurate.

PARTICIPANT PAGES – SKETCH WITH WORDS...

SUZANNE MC NEILL, MARY CAUGHEY, CHERYL MAZE, GALE EVERETT.

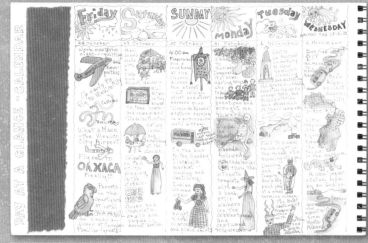

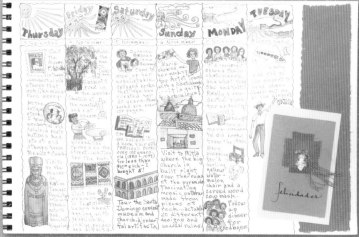

Postcards on watercolor paper 4" x 6" - pen and watercolor

It was fun to share experiences. Each day I sketched and wrote a postcard. They bring back fond memories and made a great addition to my sketchbook when I returned home.

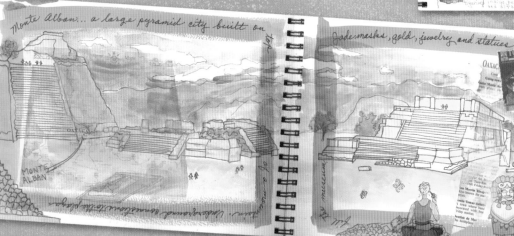

Monte Alban, Oaxaca, Mexico

7" x 9" - collage, pen and watercolor

Sketching at the pyramids.

Calendar pages

11" x 15" - pen and watercolor

Every day is full of adventures. I created a 'time line' calendar showing just tiny sketches and descriptions of the experiences and sights that appeared each day. I even included a weather report, and I'll know where we stayed and what we did. It is amazing that so much can be packed into 11 days!

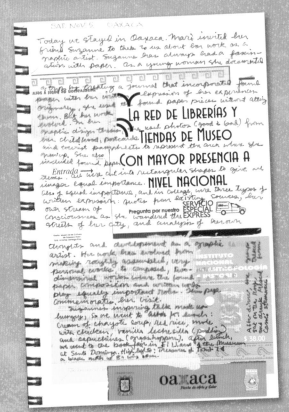

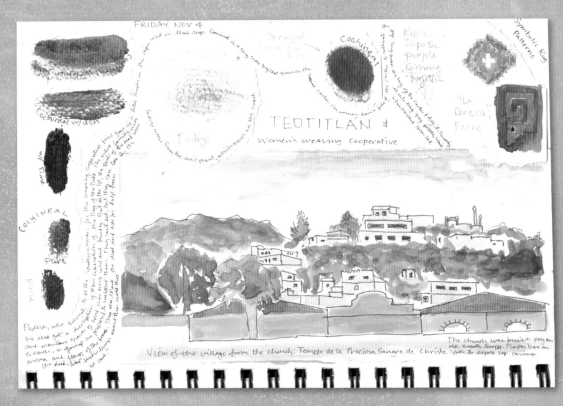

One morning in Oaxaca, Mari invited her friend Suzanne to describe her personal evolution as a graphic artist. Suzanne is fascinated by "found paper," and showed us how she used it, first in documenting a trip that she took as a young woman. Her work evolved from being completely rough and spontaneous to being highly complex and composed.

Suzanne's talk inspired me to create a page based on my interpretation of her work. After the morning workshop, we spent the day visiting sites in Oaxaca City, and I collected paper items along the way. I created a collage from the accumulated paper, and then pasted a sheet of mylar over the collage. On the mylar, the paper scraps are impassive, but the words give the page substance and life.

The trip to Oaxaca was my fourth sketching trip with Mari. In most ways, these trips are joyful. The dark side of these wonderful sketching trips comes when your right brain is asked to wake up and do something. Like a bear rousing after a long hibernation, it is out of practice, and cranky!

It turns out that with a little exercise, sketching becomes a pleasurable experience. You lose yourself to the process of intently seeing your subject and transferring that image to paper in lines and color. Mari says it over and over again: "It's the process, not the product!" When you finally do give yourself over to your subject and your pens and paints, you discover that you are happy with your imperfect sketches, because you were happy creating them.

Mary Caughey, 2005

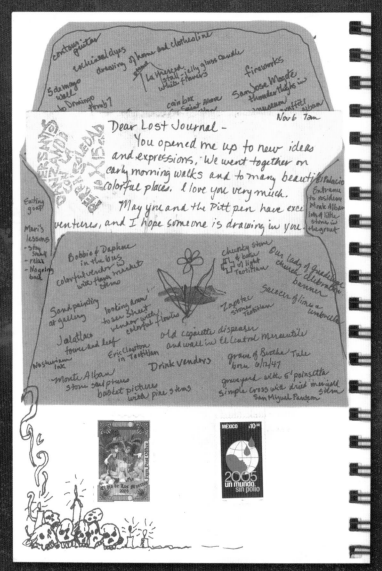

of us went to the nearby cemetery afterwards because all the graves were adorned with glorious flowers and bright colors in honor of the celebration. Right away I picked out a beautiful grave to draw, then felt compelled to see the name on it to complete my sketchbook page. When I pulled back the marigolds, I saw that it was a woman, born on June 12, 1947 --- my birth date. It affected me deeply, and I began to tremble and cry. Fifteen minutes later, I was drawing a five-foot poinsettia at another grave, but the tears were still coming down my cheeks. This was not normal behavior for me!

The next day we went to a large, lively outdoor book fair in Oaxaca. I've been a bookseller in the U.S. for thirty years, and was thrilled to be there with Latin American booksellers and authors. Excited, I set down my journal to look at the books and, despite frantic retracing of my steps, never found it again. All those drawings from the past eight days, gone. I was so sad, and was beginning to question my sanity.

That night I couldn't go to dinner, but instead stayed in my room, grieving, and began a new journal. After midnight I created a collage showing a female skeleton in high heels grasping my journal with ringed fingers. (When my daughter, Madeline, saw it later when I returned home, she said, "That looks like Grandma." I had not seen the resemblance until then.) The next morning, before breakfast, I wrote a cathartic good-bye letter to my lost journal, and listed all the drawings that were in it, over thirty. After breakfast, we traveled to the archeological site Mitla, with the second journal secure in my pack.

On the eighth day of my trip to Oaxaca with Mari, our group went by local bus to Teotitlan del Valle. We were in Mexico to sketch all aspects of the traditional celebration of the dead, Dia de los Muertos.

On the way, we stopped in the village of Tule to see the biggest tree in Latin America. Several

I called home that evening and my daughter told me my ninety-year-old mother had died the afternoon of November 4, the day I was in the cemetery at Tule. I was distraught that I hadn't been with her when she died, and found myself grieving a third time. There we were, immersed in a warm, colorful culture that celebrates death as a normal part of the cycle of life, that builds elaborate Day of the Dead altars to welcome their deceased family members back into their homes each year. As we talked, I began to see the connections, to feel blessed and destined to be in Oaxaca, helping me to bear my loss. Being there—reveling with the locals and drawing, drawing—opened me up to senses I hadn't known before. My new sketchbook has only a few drawings by me, but also ones kindly given by other members of the tour group. I look at them with fond memories of Oaxaca and my unexpected journey: understanding the close ties between the living and the dead, not just for the Oaxacan people, but for myself too.

Cheryl Maze, Oaxaca, 2005

Sketchers! Before you pack your bags or make your first sketch, write your name, address, and country on the inside of the front cover! Consider including your hotel name if you are staying in one place. With luck, the lost will be returned.

Mari

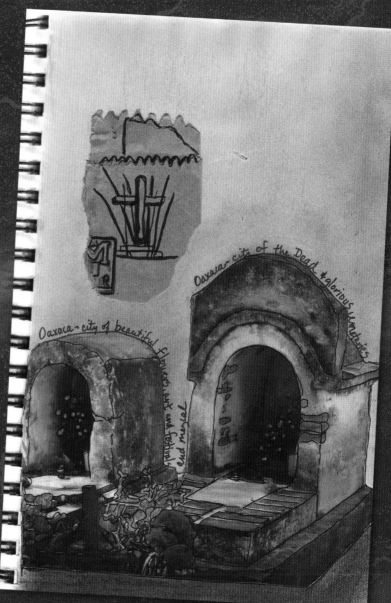

Oaxaca ~ city of beautiful flowers, park and festival and mezcal

Oaxacan city of the Dead & glorious memories

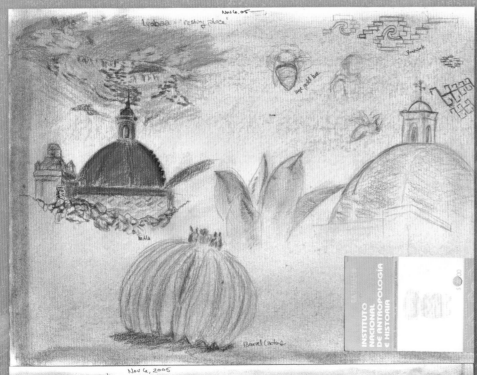

Playing with words was a concept brought up on my first sketching journey with Mari to France. I had never thought of combining sketches with words until then. I had learned during art school that sketching was a necessity for working out ideas on projects. It was not a place for my daily thoughts and experiences since I had to turn them in for grading.

With Mari's encouragement I experienced the freedom to be creative, to immerse myself in colors and to use words as an expressive part of images.

Now sketching is enjoyable every day.

Oaxaca, Mexico
I carry my sketchbook everywhere. I chose a book that is large enough to record my words and drawings, but is small enough to be portable. I have the freedom to draw and journal everything from small parrots to domed buildings and from fruits to vases. When I return home it is enjoyable to experience my trips again and again by simply opening my book of memories.

Initially, I played a bit with wrapping sentences around images on the France trip, but it was not until Oaxaca, Mexico, that the concept really took root. Oaxaca was intimidating for me because of the denser population and my lack of Spanish. I was uncomfortable drawing in public. Therefore, writing aided the scarcity of sketches.

I used two methods. The first was just jotting down quick interpretations of things going on around. Quick short sentences placed near a sketch let me know things like color or extra stimuli. I also noted the date, signs or locations. The second was more of a journaling style. I would launch into greater descriptions of daily events. These writings became a way to capture visual images.

I enjoyed the fact that there were no lines to follow just sketches. Sentence structure and punctuation were unnecessary. It was just a way to remember key points of the day. A year after the trip, I discovered the writing brought about richer images in my memory. Writing helped free my mind of the extra sights, sounds, and smells of each day. The writing concept has continued in my life. Currently, I write daily to lessen cluttering thoughts that hinder creativity.

Gale Everett,
Oaxaca, Mexico, 2005

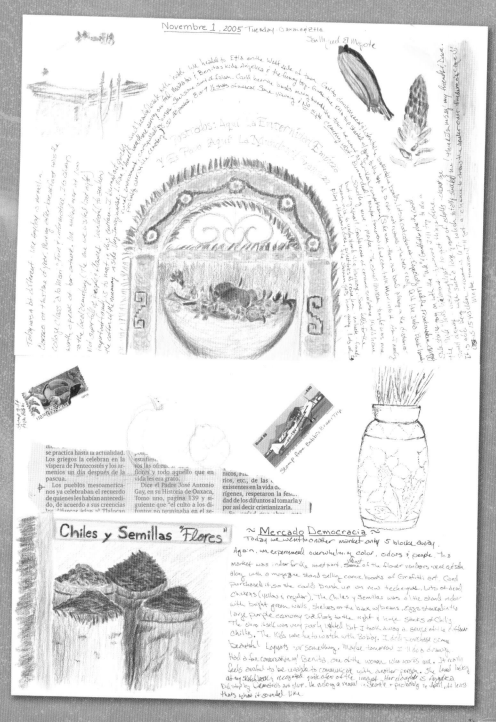

Traveling with a Sketchbook...
A Cultural Experience

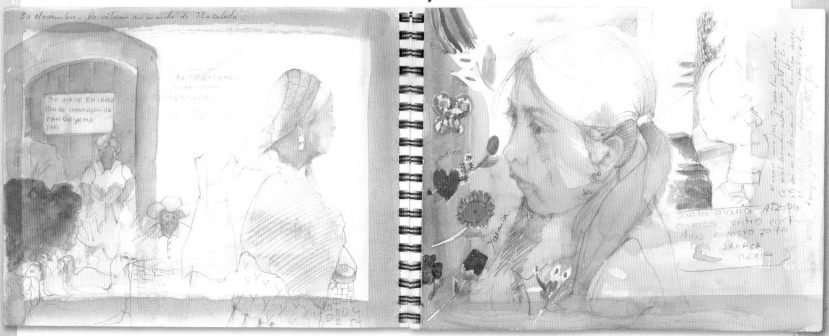

October 30th, Tlacolula, Sunday market.

The day before El Día de los Muertos: The excitement is high! I sit on a step away from the crowd where I can observe the constant flow of people. Across the street, a couple of vendors are selling beans and turkeys. Kids come and gather next to me. They watch me as I set out my watercolors and a few pencils and seem fascinated when I start sketching. I lend them sketchbooks, brushes and pens. We chat as we paint. I draw Yasmina. Her mother, who stands next to me, smiles and nods "yes" when I ask her permission to draw her also. When the family leaves, I take a moment to cut and paste the children's hearts and flowers onto my page.

Then, I walk to the churchyard away from the crowd. I sit against a red pillar across from an Indian family. They speak Zapotec with animation. I start sketching at the bottom of the page. The red pillar, the sounds, the smells... I am so fascinated by the beauty of the moment that I do not realize when the shoulder of the old man, sitting on the white wall with a young boy, appears on my page. The family has noticed my stare going back and forth from the "abuelo" to my sketchbook. They whistle at me, quite angrily, asking me to stop sketching the old man at once. I sheepishly packed my supplies and left the churchyard, feeling ashamed and sad.

In one day, I had two completely opposite cultural experiences. It was a great reminder of how careful and sensitive we have to be when traveling in a different culture...

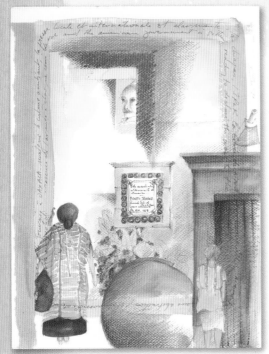

Traveling with a sketchbook allows you to experience a culture in a different way. Being there humbly with a sketchbook, you open a dialogue that makes you closer to people. But, you must remember the importance of being culturally sensitive. If you want to sketch someone, ask permission before you do, unless you are doing "gesture" and it only takes you a few seconds to record. In many cultures, the belief is that whenever you take a picture or draw someone, you are stealing their soul. For that reason, I always sketch people from the back. Even then, I still feel like a "voyeur".

The only "portraits" I have done are of people I got to know and befriended. While I draw, we chat about their life, their family, and their home, and I feel very privileged to experience that intimacy.

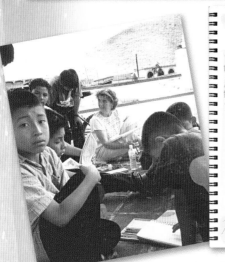

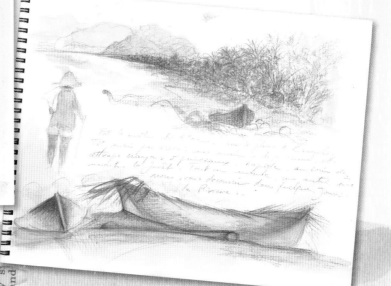

Three days before Christmas, Oaxaca, Mexico

I walk away from the busy crowd and take refuge in Xochimilco. It is so quiet here! I sit on the doorstep in front of Piñatas Rossy and start sketching. A small boy is sitting by the corner, we chat. He tells me his name is Juan Miguel and that he is taking care of his aunt's "tienda". I ask permission to include him in my picture. He nods, "Si." After a few minutes, he comes to sit next to me and puts his head on my shoulder. He asks, "Are you American?" I answer, "No, I am French." Seeing his puzzled look, I ask if he knows where France is. He shook his head. I draw a map of the two continents. We stayed there, chatting and drawing in the shade of the doorstep through the hottest hours of the afternoon. At the end of the day, I had a new friend!

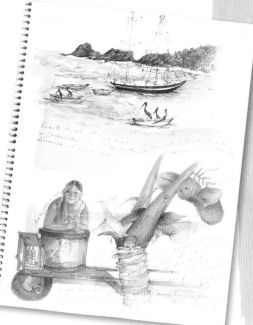

When you are sitting on a doorstep or on the sidewalk, both children and adults will stop to see what you are doing. They are interested to see how you view their world. They may stay a long time looking silently over your shoulder. It always amazes me how respectful people are.

Children may giggle and talk softly. Try not to feel shy or ashamed, the humbler you are, the more accessible you are. Think that, instead of intimidating people, you may encourage them to record their life as well. If they are children, lend them some crayons and paint and let them sketch, even on one of your pages!

Sketching on the Beach
Puerto Angel, Oaxaca, Mexico

When I look up, I have kids all around, silently, watching me sketch. They all have something to peddle, but no one asks if I want to buy. Ana asks me if I would draw her. I am delighted. In the full sun, she poses with no thoughts for the ice cream in her chest. No one moves. An hour goes by…

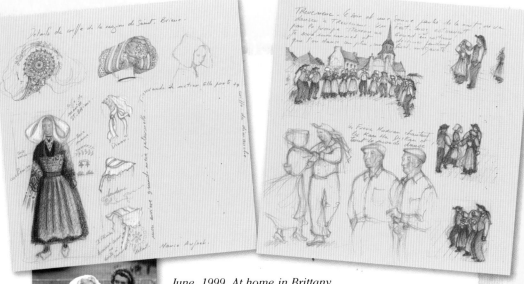

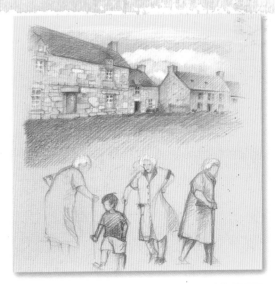

A day sketching in Lanrivain, Brittany

June, 1999, At home in Brittany

I am working on my book, "Carnets de Bretagne". I need to sketch "coiffes", headdresses. I hear about a "Fest Noz", a night festival of folk dancing where I will be able to see traditional costumes. There, I meet Madame Le Calvez. While I draw the intricate laces of her coiffe, she complains about aches and pains. However, when her husband comes to invite her to dance, she does not hesitate and cuts a fine figure on the dance floor. No more aches or pains!

When I am sketching, I slow down to better observe. My mind is clear, I lose track of time, totally aware of sights, sounds and scents. I feel light and happy.

To me, sketching is like having another passport. It makes travel experiences more meaningful and sets us apart from regular tourists while we record life as it is.

BELL RINGERS
TRES A LA LUNES —
TRES A LA MARTES

PEDRO
JUAN CARLOS
HUGO
JUAN CARLOS
CELESTINO
VALLENTINO
OSCAR
FELIX
FELIMON
FORTINO
DANIEL
Gerardo

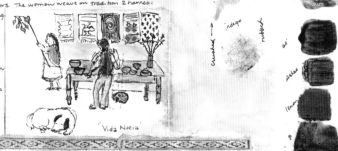

nopal
lives
just one
year—
3 harvests

not many
spikes

Cochinilla
mixed

Cochinilla
mixes

dry cochinilla
bugs

baby cochinilla put on nopal to grow...
after 4 months they are scraped off + dried.
With a morter + pestel they are crushed to a fine powder.
The powder is mixed with either lemon or ash for a
variety of colors. The women weave on tradition 2 harness
looms — standing.
They spin + dye
the wool, weave
the rugs with
traditional
patterns kept in
their minds.

The indigo plant is
harvested + the
bark + branches
ground to fine
powder.

Vida Nueva

indigo

Day 7
We visit a Women's Collective to see the dyes + the weaving. We bought a rug for
our home + supported the collective's work in educating women.

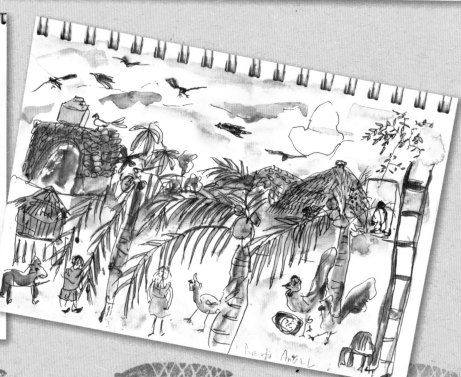

Puerto Angel

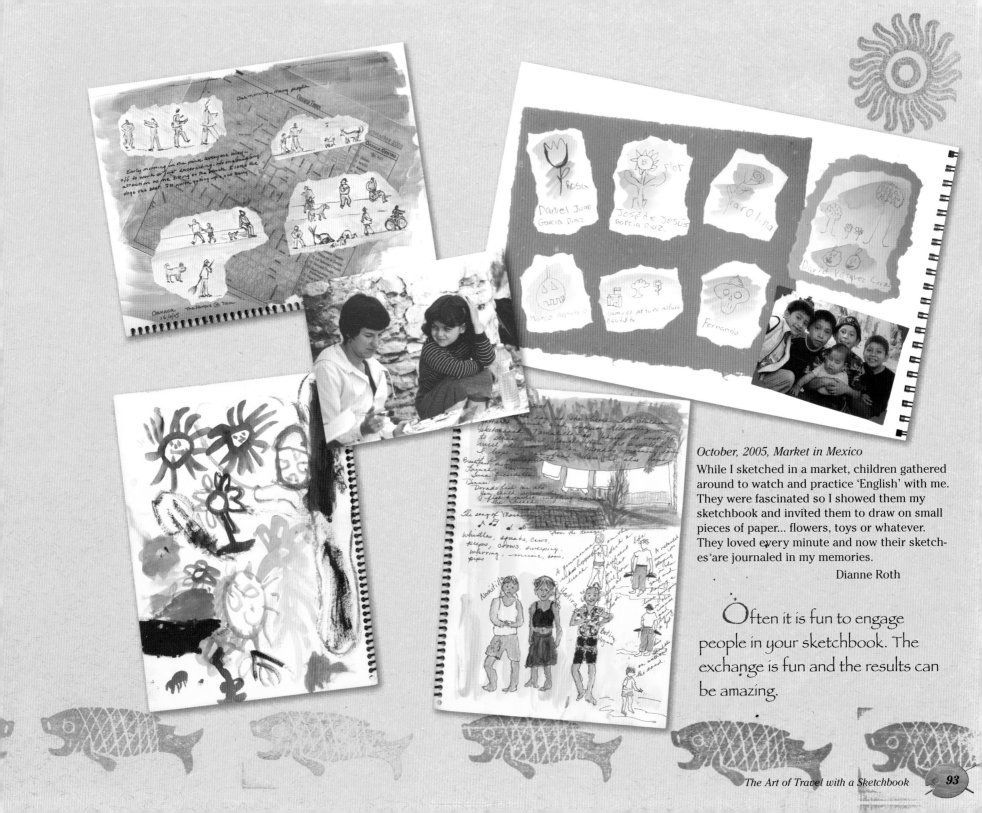

October, 2005, Market in Mexico

While I sketched in a market, children gathered around to watch and practice 'English' with me. They were fascinated so I showed them my sketchbook and invited them to draw on small pieces of paper... flowers, toys or whatever. They loved every minute and now their sketches are journaled in my memories.

Dianne Roth

Often it is fun to engage people in your sketchbook. The exchange is fun and the results can be amazing.

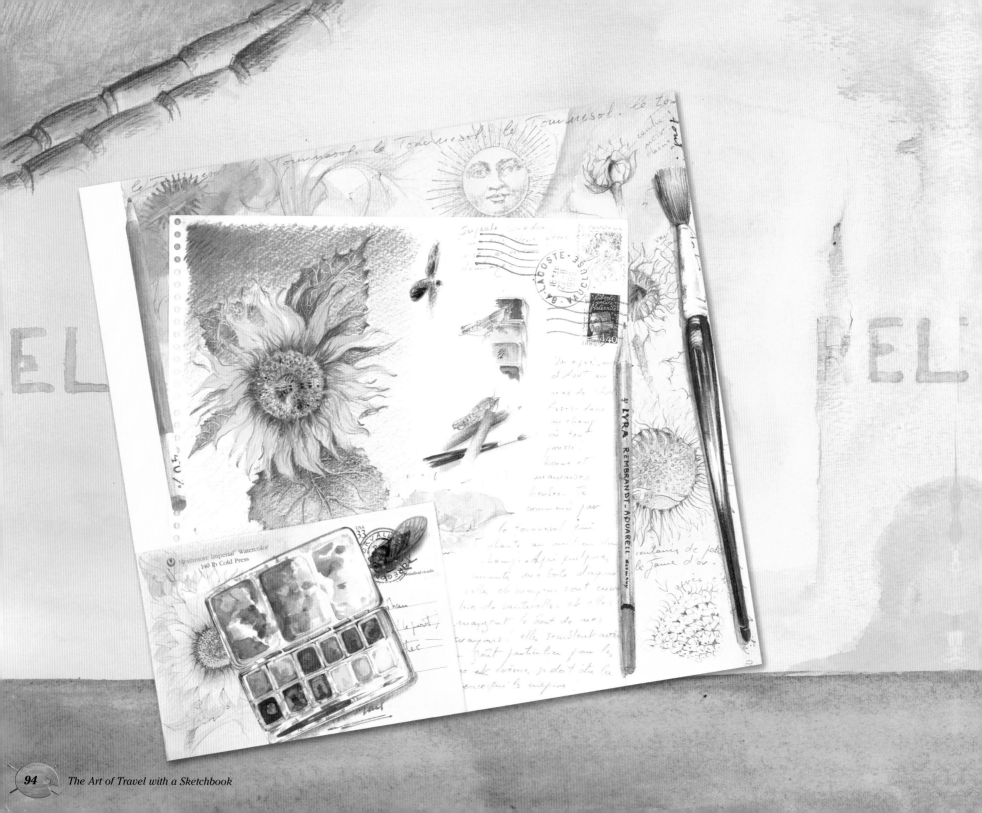

A few words to conclude…

Now that you understand that you are not expected to create art books, combine all of these six tips and start sketching, today. You too can record your travels and your life! Have your sketchbook and a pen on hand at all times. Sketch your teapot, your cat, your garden, get the fever! Pack your backpack and start walking anywhere, with no agenda, no intention in mind.

At the end of the day, you will have told stories on your page. You are unique and, with experience, you will develop your own style and have your favorite tool to play with. And no matter what you have done, your lines and colors will bring your memory back to that very moment.

So, what is a travel sketchbook? …a notebook full of impressions, observations and memories? … your very own intimate journal in which you record your private life and emotions? … a travel companion for your adventures? For me, it is all of these. It is a place where I can express myself with total freedom and celebrate life. Ultimately, whether you sketch in your own backyard or in an exotic faraway land, it is always the adventure of seeing! Bon voyage and happy sketching!

I am forever grateful to my participants for sharing their sketchbooks and their experiences in this book. They continue to inspire me and change my life as a "sketcher".

Recommended resources:
"The Zen of Seeing", Frederick Franck
"Living Color", Natalie Goldberg
"Every Day Matters", Danny Gregory
"Sketchcrawl", http://www.sketchcrawl.com/

Karen J. Kreamer grew up in Virginia and North Carolina and now lives in Corvallis, Oregon. She has a degree in Nutrition and worked in hospitals until retiring in 2006. She has had a lifelong interest in drawing and painting, watercolor and collage. She has attended three sketch journal workshops with Mari in France…to Provence, Le Lot and Brittany.

Barbara Bacon Folawn has enjoyed an appreciation of art and nature as well as French language and culture since childhood. With little formal art training but an enthusiasm to develop this interest, she joined Mari's sketching trips to France beginning with Provence in 1999. Barbara so enjoyed the relaxed approach to traveling with a sketchbook in hand that she continues to carry one with her on each trip, whether exploring the beautiful Pacific Northwest or a friend's small backyard garden.

Sandy Segna had drawn some black and white sketches with charcoal and pencil before her trip with Mari. But Oaxaca was full of color! So Sandy used anything she could find to color her sketchbook—pastels and watercolors, flowers and leaves, seeds from the market—to bring home images of her Oaxaca experience.

Roberta Wallace is a retired psychologist who had never sketched before going to Brittany with Mari. She always says she could only draw stick figures. The Oaxaca trip was her second with Mari's group and she fell in love with the colors and people of Oaxaca. Now she is always sketching and working on her ability to capture sights and people more quickly and colorfully. Her entire retirement and every vacation have changed completely!

Carol Chapel is a painter and printmaker who lives on ten acres in rural Oregon, along with her husband, four draft horses, a dozen sheep and a border collie.

Gale Everett is a native Oregonian living and working in the mid Willamette Valley. As an artist, she works in a variety of media including printmaking and ceramics. When she is not traveling to different corners of the world, she shares her life with her husband and a houseful of animal friends.

Barb Campbell is a ceramist. She participated in a couple of sketching workshops in Oaxaca, which led her to a deeper understanding of a different place and culture. She now lives and works part of the year in Oregon and Mexico.

Dianne Roth is a retired schoolteacher, a writer, and a sketcher. She carries her sketchbook with her on travels around the world and in her own back yard. She loves hiking throughout Oregon where she lives.

Ted Ernst is an environmental scientist and studio potter. Before going to Oaxaca with Mari, he hadn't sketched anything other than pots since elementary school. Although he initially agreed to the Oaxaca trip to indulge his wife for her 50th birthday, he quickly became enthralled with traveling with a sketchbook.

Joan Elisabeth Reid took up watercolor painting later in life. She wanted to learn to work rapidly and freely while traveling so that she could fill sketchbooks of what she saw. Participating in "Traveling with a Sketchbook in Hand" trips to Oaxaca and Brittany with Mari provided wonderful opportunities to develop the art of sketching. Looking at travel sketches immediately transports the artist back to the moments when those sketches were produced.

George Norek practiced Chinese calligraphy since 1981. He does it every morning. It is how his day begins. He discovered sketching in Provence in 2006 and how he could tie sketching to calligraphy.

Prue Kaye had a fear of drawing and had never tried to sketch. She is a retired nurse and she sings in several choirs. Gardening is a first love and since starting to sketch, has found lots to draw in her own backyard. She now keeps a little sketchbook with her. She says waiting is easy if you sketch to while away the time.

Mimi Shawe had her first sketching experience with Mari's workshop in Oaxaca in 2005. Sketching proved to be so much fun that she now takes a sketchbook and pencils on all trips. Between trips there is always local material to keep busy with.

Nicole Denis is a retired French schoolteacher, who discovered sketching late in life in one of Mari's workshops in Provence. Convinced for many years that she was unable to draw, she discovered a new passion and is playfully exploring new techniques, new media, and new horizons.

Marilyn Madau is French and a Buddhist practitioner. She decided to attend Mari's workshop because her approach resonated with her spiritual practice. "Slow down, be aware and observe"…

Cheryl Maze is a retired bookseller living in Corvallis, Oregon. While she took several art classes years ago, she did not start sketching until Mari's Oaxaca tour. She is an avid gardener, and feels that sketching is the best way to see minute details of nature.

Betty Bernard lives in Baltimore. She had always painted with oils before joining Mari's workshop in Oaxaca. On the second day, Mari demonstrated pastels. The joy of working with your hand, sand and mixing colors started a love affair that still continues.

Mary Caughey grew up appreciating the natural beauty of Oregon. She now lives in Portland. In 2001, she joined Mari's Provence workshop and discovered that traveling with a sketchbook enhances the memories of her travels.

Karen Kenyon, a retired librarian who loves to travel, lives in Astoria, Oregon, with her husband and three kitties in a house overlooking the Columbia River. She is a beginning artist who is learning to work with watercolors and colored pencils.

Margaret Anderson is the author of both fiction and nonfiction books for young readers. *Children of Summer: Henri Fabre's Insects* (Farrar, 1997) is illustrated by Mari le Glatin Keis. While doing research for the book, she took part in Mari's first sketching workshop to Provence and discovered sketching.

Suzanne McNeill loves to travel and experience different cultures. In her travels from Mexico to Brazil, from Thailand to Morocco, from Belgium to Italy, and from Tahiti to Australia…Suzanne has been enriched by brilliant colors and charming traditions. Suzanne's love of art and handcrafts has influenced her life by allowing her to meet interesting creative people at home and around the world.

41

Make Each Day in Life More Meaningful

The Art of Travel with a Sketchbook